BARNS FARMS & ROLLING HILLS OF CHESTER COUNTY

JEROME M. CASEY

SCHIFFER
PUBLISHING

4880 Lower Valley Road · Atglen, PA 19310

Designed by Jack Chappell
Cover design by Molly Shields
Type set in GeoSlab 703 XBDd BT/Futura

ISBN: 978-0-7643-5756-5
Printed in China

Published by Schiffer Publishing, Ltd.
4880 Lower Valley Road
Atglen, PA 19310
Phone: (610) 593-1777; Fax: (610) 593-2002
E-mail: Info@schifferbooks.com
Web: www.schifferbooks.com

For our complete selection of fine books on this and related subjects, please visit our website at www.schifferbooks.com. You may also write for a free catalog.

Schiffer Publishing's titles are available at special discounts for bulk purchases for sales promotions or premiums. Special editions, including personalized covers, corporate imprints, and excerpts, can be created in large quantities for special needs. For more information, contact the publisher.

We are always looking for people to write books on new and related subjects. If you have an idea for a book, please contact us at proposals@schifferbooks.com.

DEDICATION

This book is dedicated to my family—my wife, Patty; my children, Ryan, Stephanie, Jaclyn, and Matthew (and his wife, Bobbie Ann); and my beautiful granddaughter, Kylie—my friends, and all those who love Chester County, Pennsylvania.

ACKNOWLEDGMENTS

I would like to thank my mother and father, Rose Marie Redheffer and Francis X. Casey, for their love and support for these past sixty-one-plus years. I know that I have not always been easy, but it is your sense of always doing what is right and your strong-willed character that I will carry with me the rest of my life, and for that I thank both of you very much. My love to both of you, now and always.

I would also like to thank Eileen Casey, my father's wife. It makes me very happy to see my father this happy and so much in love and at peace. You have become a very important and special part of my family, and one that makes me proud.

I would also like to thank Frank W. Redheffer for introducing me to the wonderful world of photography so long ago, since without that this book never would have been possible. May you rest in peace.

CONTENTS

FOREWORD

An ancient sense of memory echoes within me whenever I ride the rolling hills of Chester County, Pennsylvania. Fittingly, fieldstone and board, green glens beginning to show tinges of fall colors, and towering sycamores, maples, and evergreens still provide shade in fading autumnal light. Images from a childhood begun on a farm, integral to my adult perspective, meld with the latter-day sights before me. It is an exceedingly difficult task to reproduce this state of being—part dream, part reality—in an image. Local history celebrates many painters who adeptly portray scenes of pastoral and seasonal beauty. This job is considerably more complicated when looking at such natural pulchritude through a camera lens. In his exquisite new book, *Barns, Farms, and Rolling Hills of Chester County*, photographer Jerome Casey has more than accomplished this feat. His love and devotion to the countryside and all the treasure contained within is palpable in his pictures. The classic Chester County stone barn, in its unembellished elegance, comes alive in every shape and size. Capturing the mood and texture of each season's impact on the beholder, Casey is highly successful in his honest artistry. His remarkable images of Radnor Hunt further underscore the immutable quality of life in Chester County. A life to be fiercely preserved, celebrated, and well lived!

Collin F. McNeil, MFH
Author of *Bright Hunting Morn: The 125th Anniversary of Radnor Hunt*

INTRODUCTION

This book represents a two-plus-year photographic journey undertaken by me through Chester County, Pennsylvania, showcasing why I consider this county above all others in Pennsylvania to be so extraordinary. Chester County is one of those very special places that allows for a simple car ride to turn into a day of magnificence, simply by slowing down and looking out the window. Many of the images seen here were taken from the side of the road and offer the very same view you may find when driving through, featuring wonderful imagery from the main roads and highways that traverse the county. However, most of these photographs I found only by turning onto the back roads, where I discovered that one can be transported back a hundred years and witness a special kind of Chester County magic.

Barns of all shapes and sizes, from the beautifully aged with their deep, rich character that only years of hard work and use can craft, to the majestic fieldstone barns standing proud on the hillsides, are full of awe-inspiring grandeur and beauty. Farms of vast parcels dot the landscape, with split-rail ranch-style fences corralling elegant horses on fields covered in geometric designs. Rolling hills of green, seemingly endless at times, shift to brilliant shades of red, yellow, and orange. This is Chester County, from east to west, from sunrise to sunset, and in all four seasons, at its best.

All photographs seen in this book were taken in Chester County, Pennsylvania.

CHESTER COUNTY

One of Pennsylvania's three original counties, formed 1682 by William Penn. Name derived from Cheshire in England. West Chester, the county seat since 1788, was incorporated in 1799. County was the scene of important military activities in 1777-1778.

PENNSYLVANIA HISTORICAL AND MUSEUM COMMISSION 1981

CHAPTER ONE
BARNS AND FARMS

"Sometimes you find yourself in the middle of nowhere, and sometimes, in the middle of nowhere, you find yourself."

—Author unknown

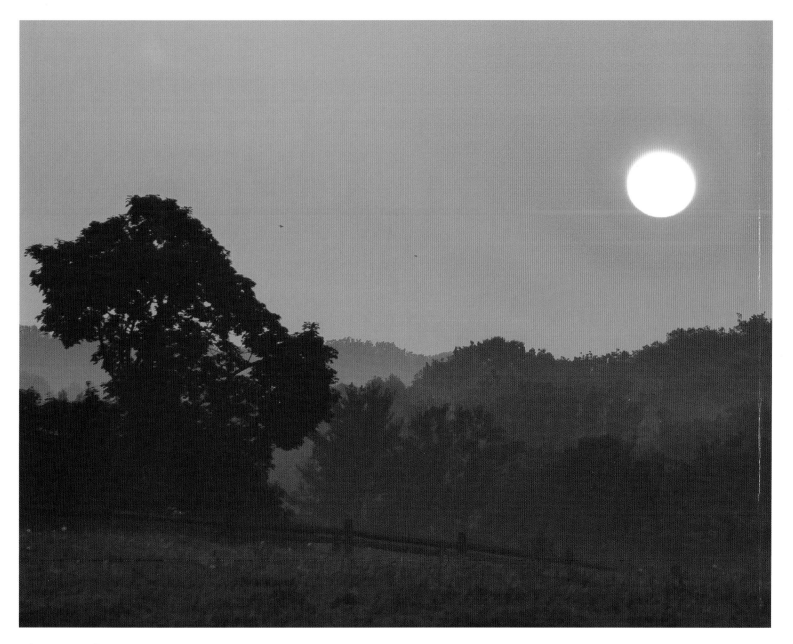

The magic of sunrise

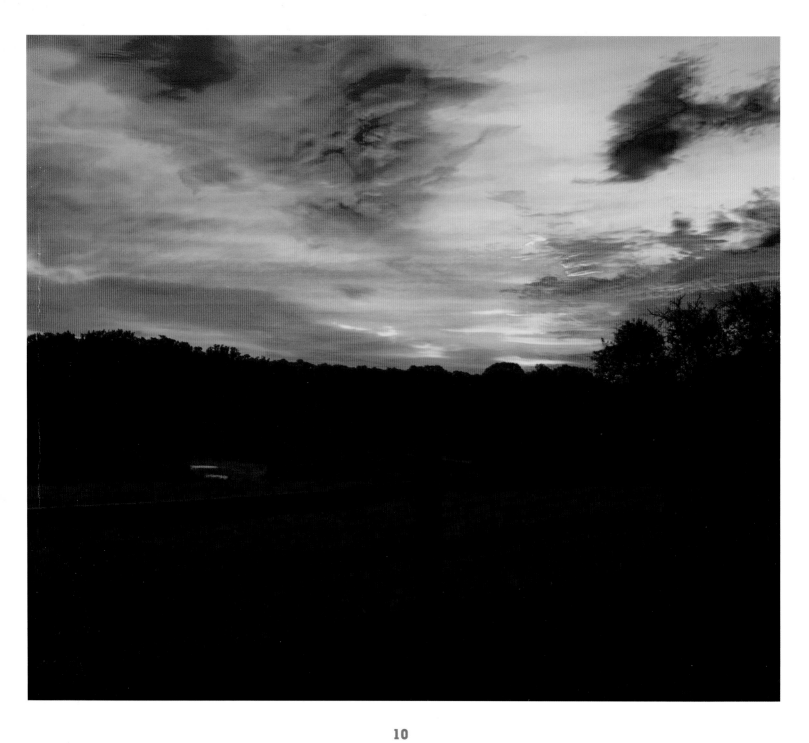

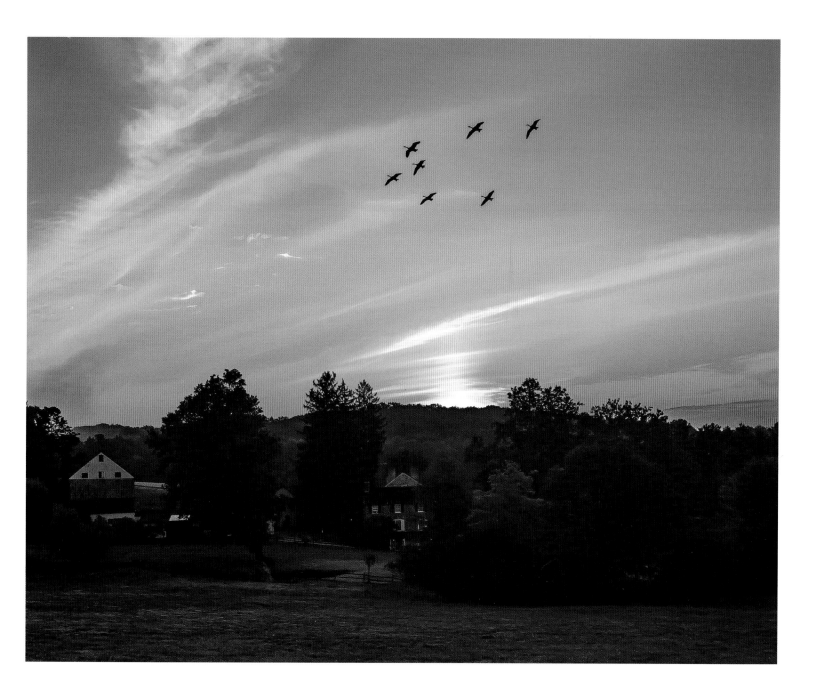

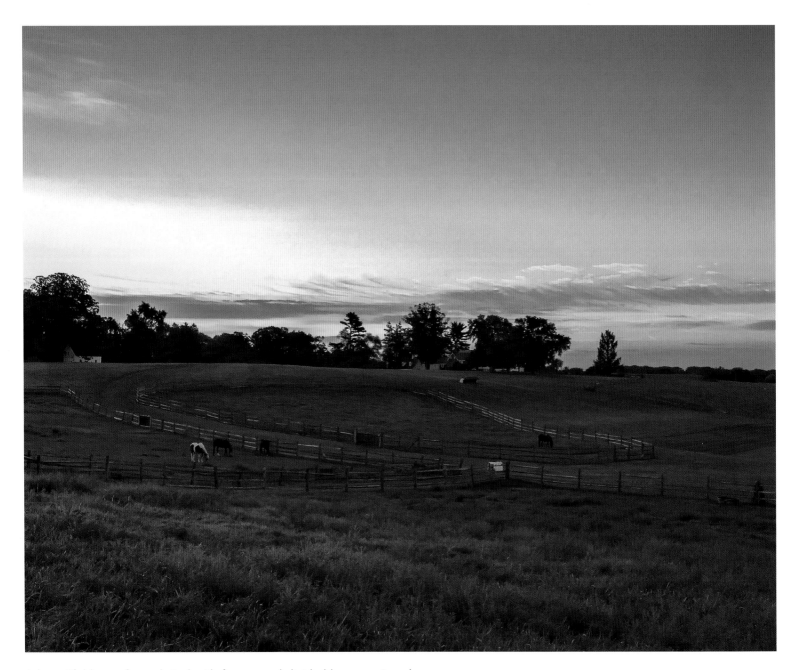

A beautiful horse farm dotted with fences and divided by sweeping slopes

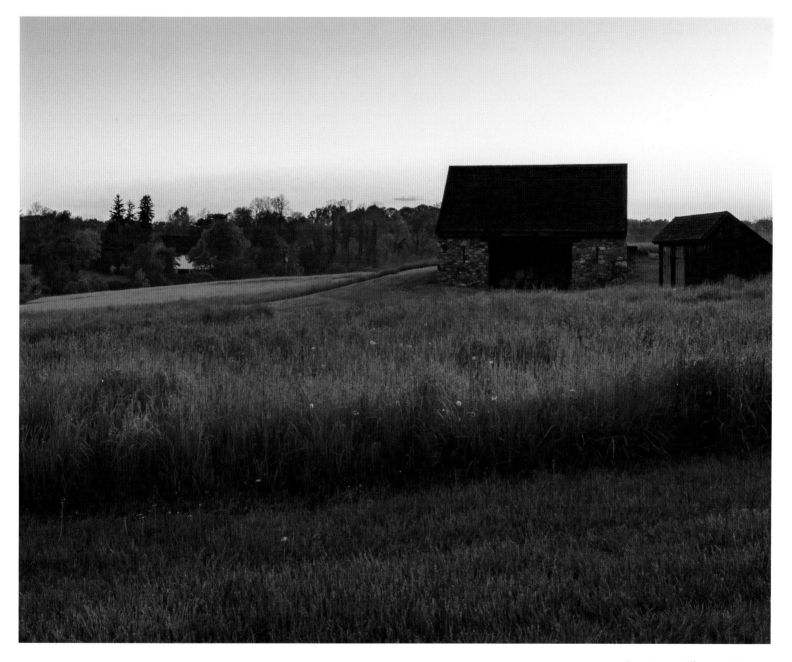

Sunrise in Chester County

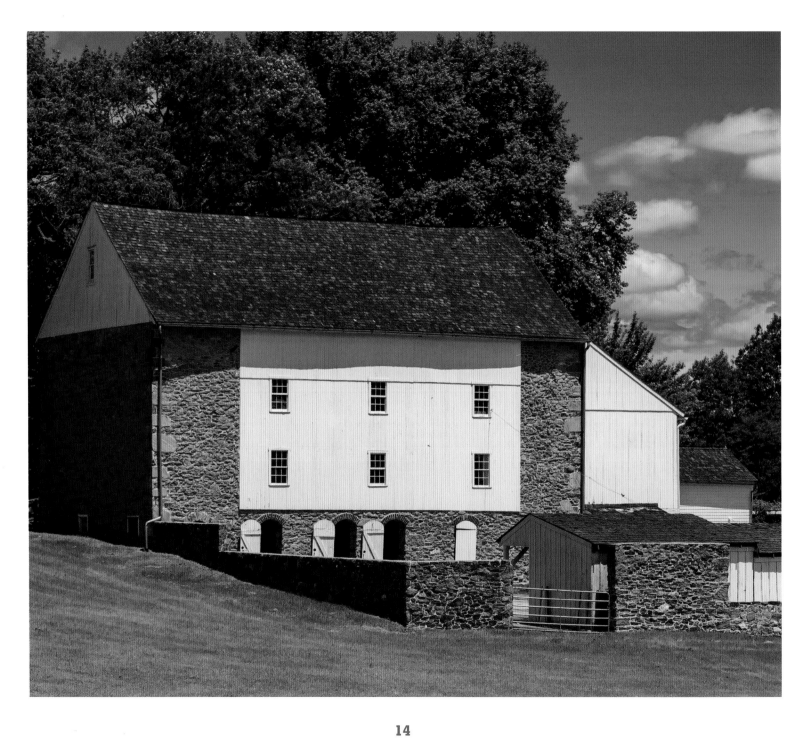

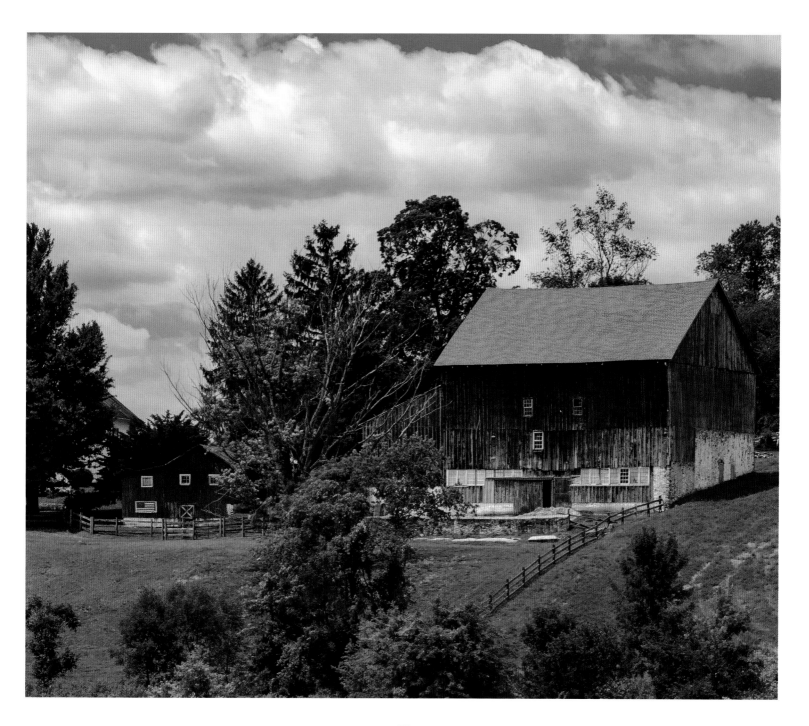

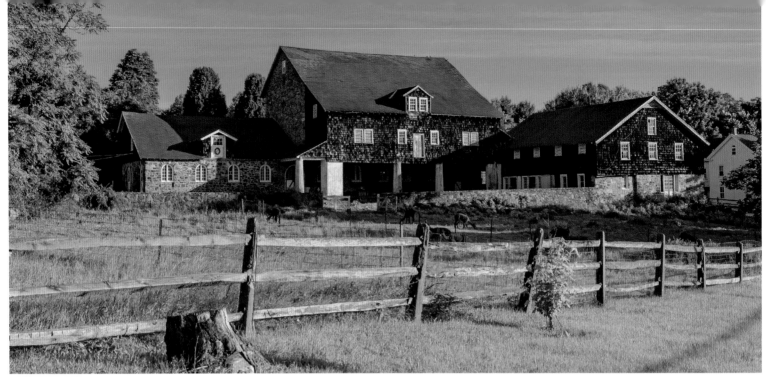
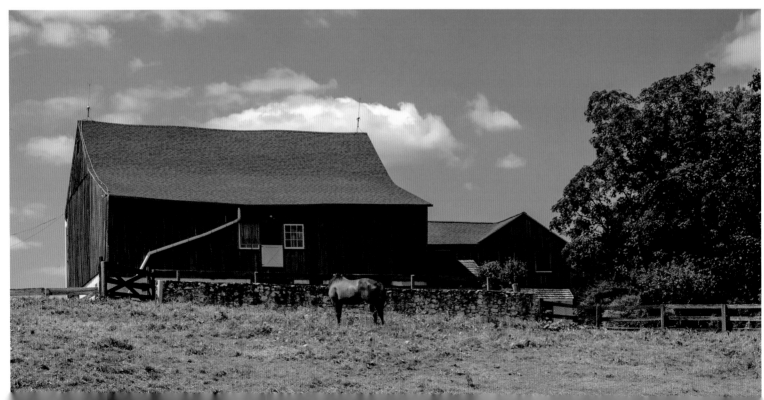

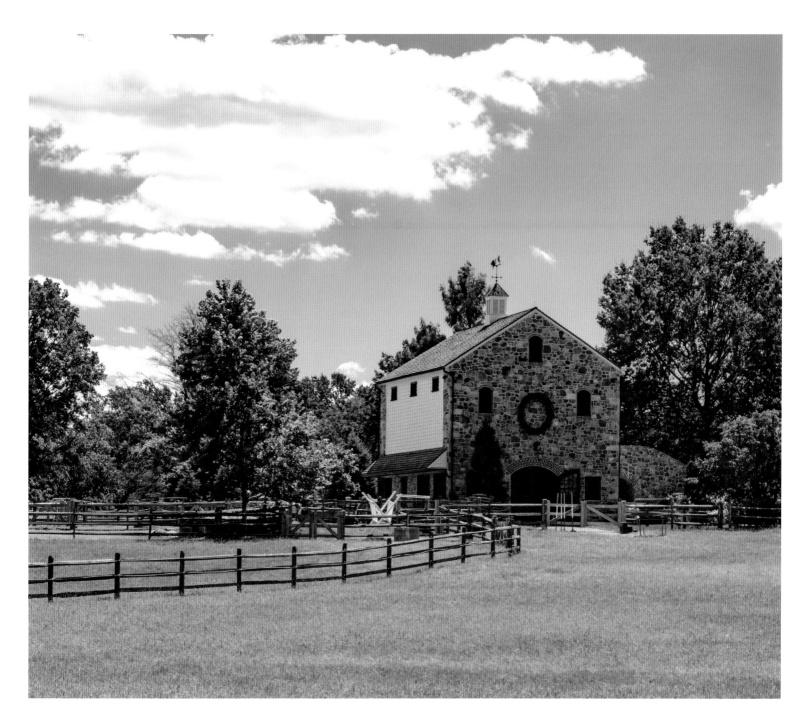

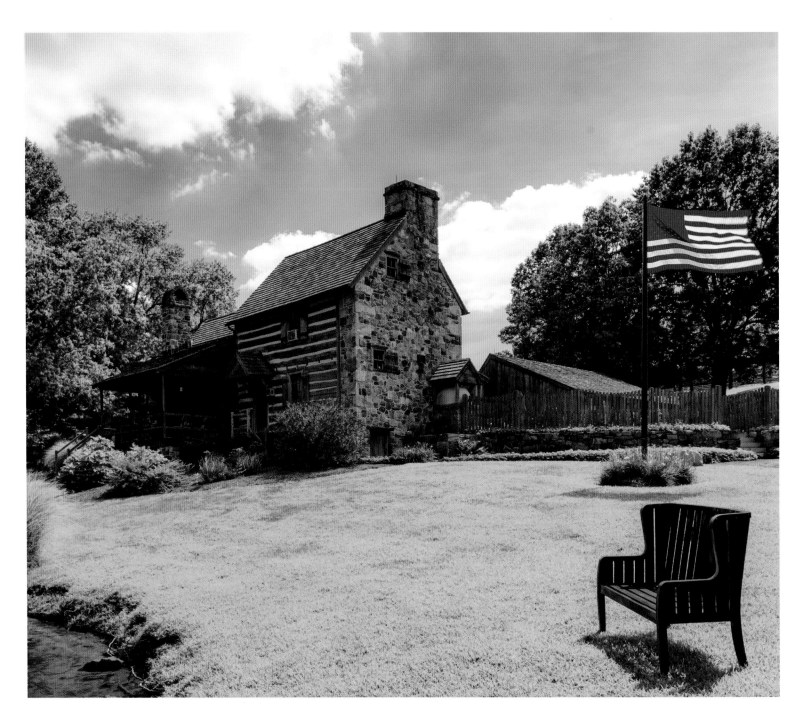

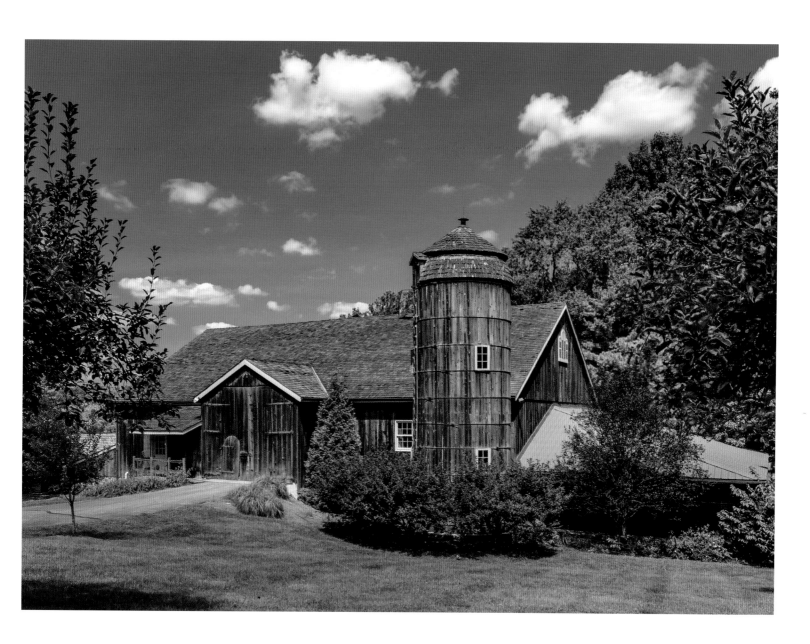

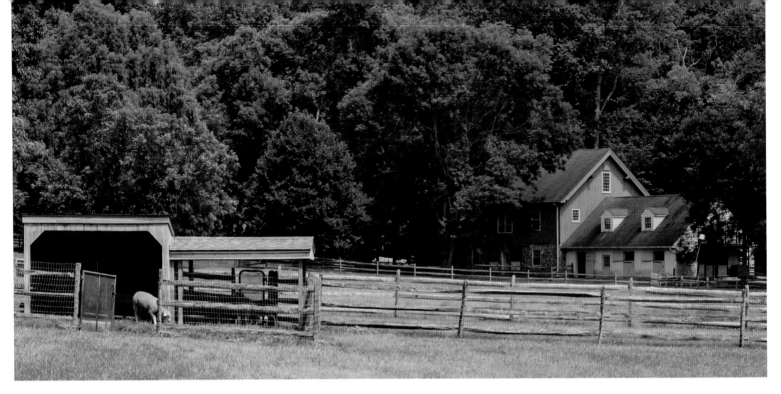
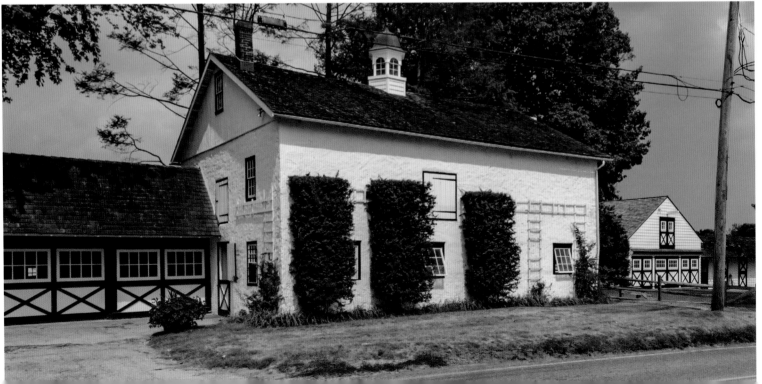

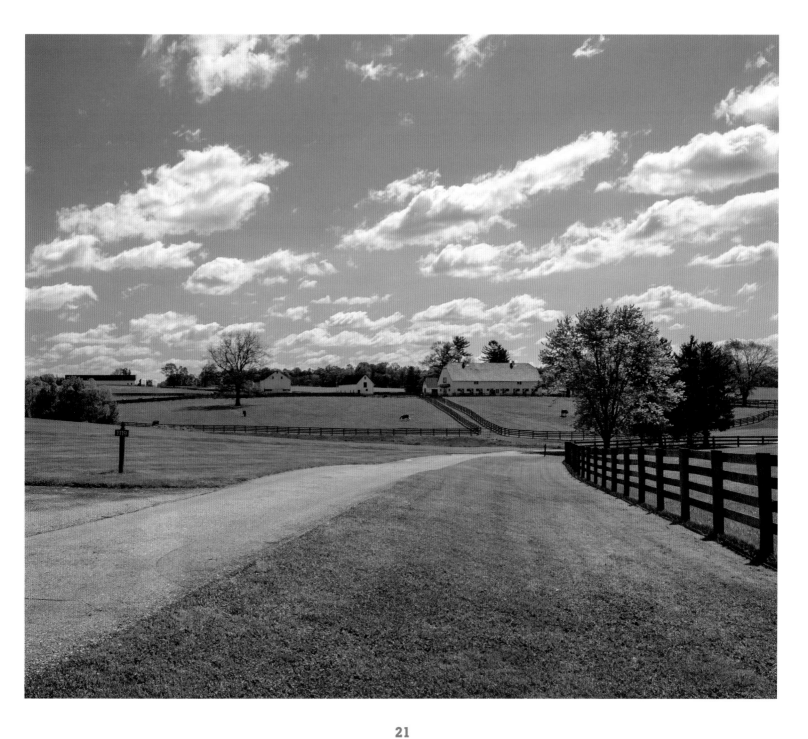

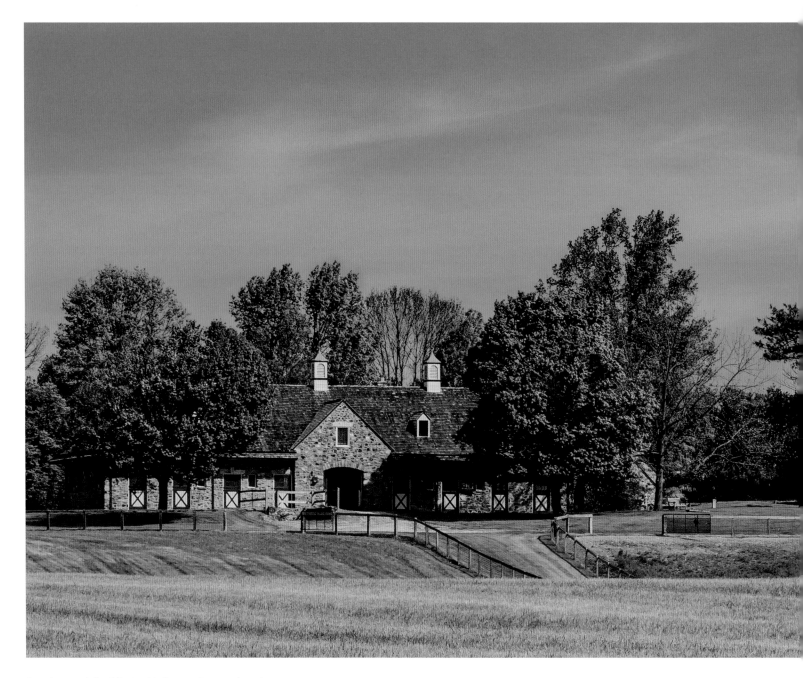

Brushwood Stable in Malvern, Pennsylvania

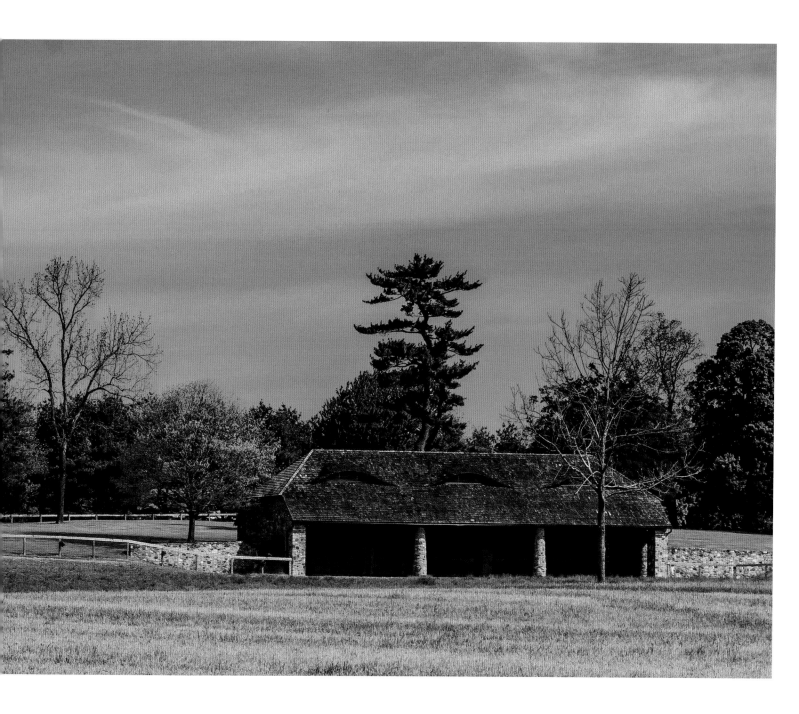

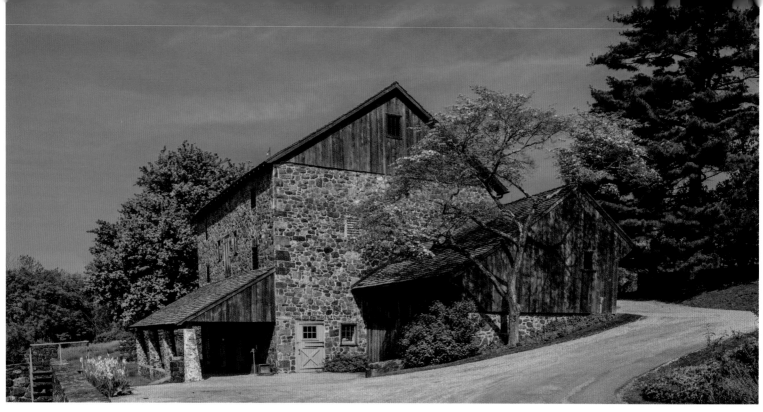
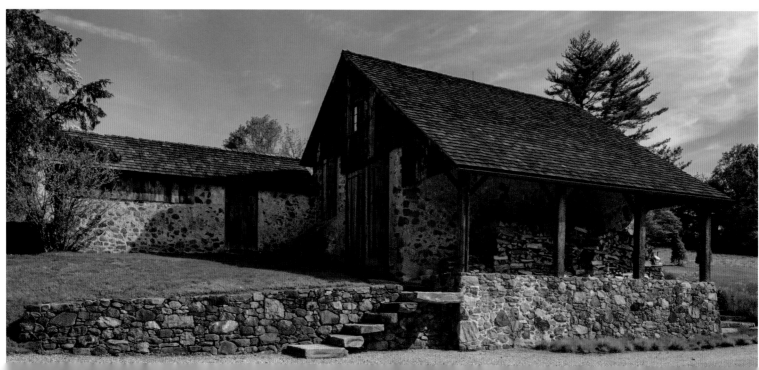

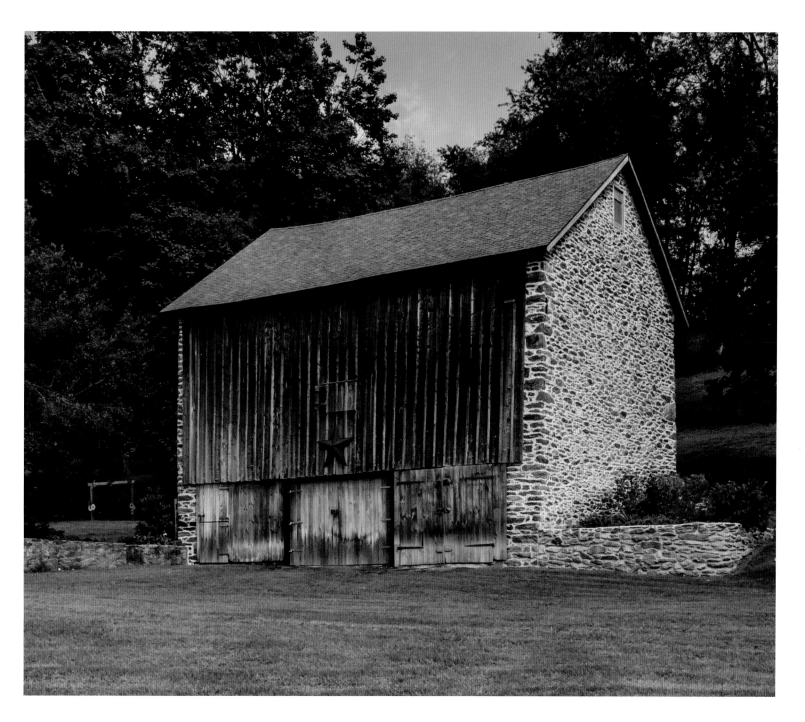

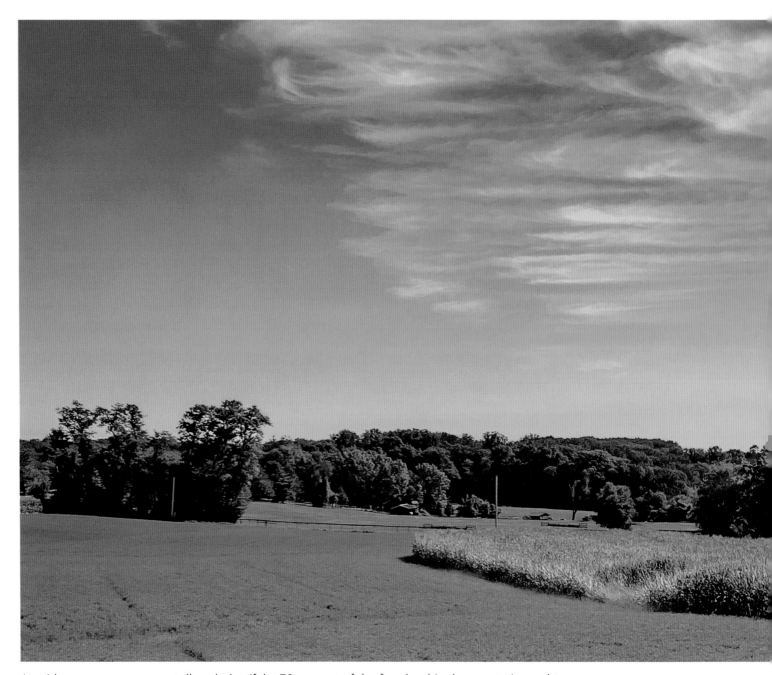

At midsummer, corn grows tall and plentiful—70 percent of the farmland in the county is used to grow crops.

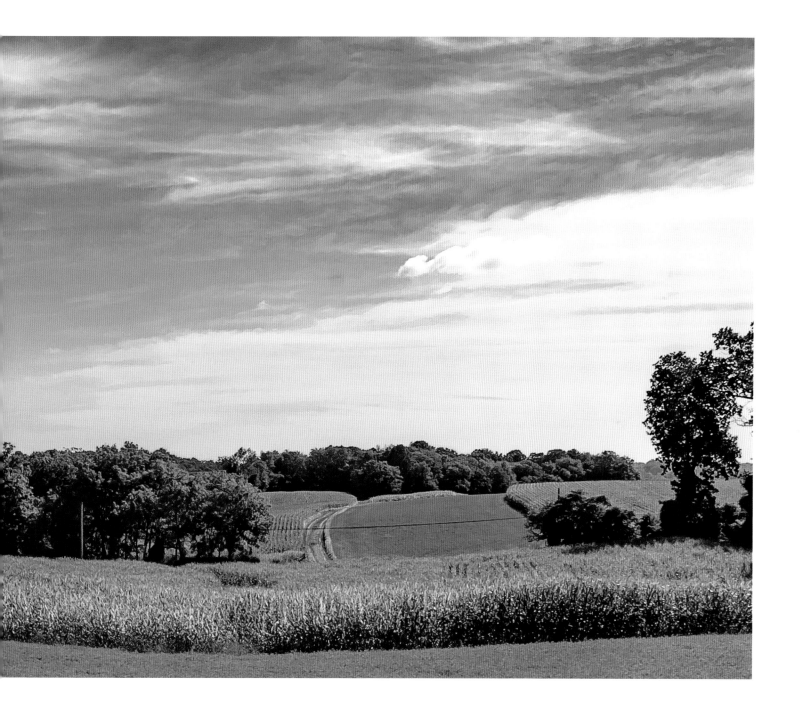

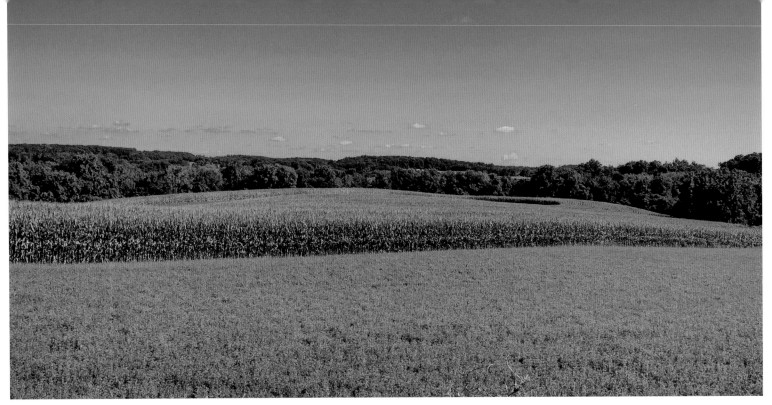

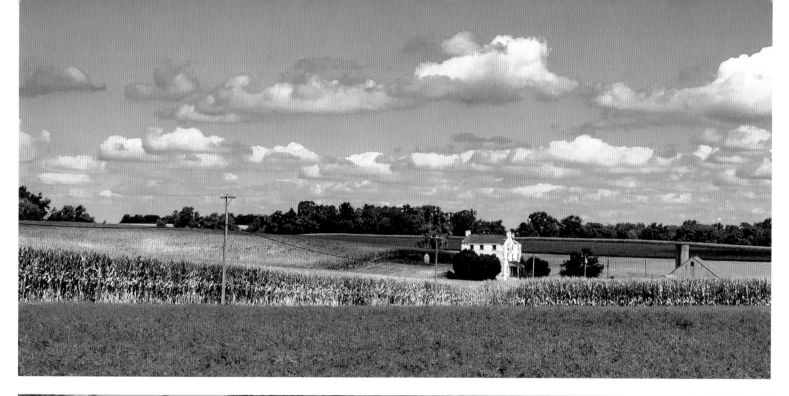
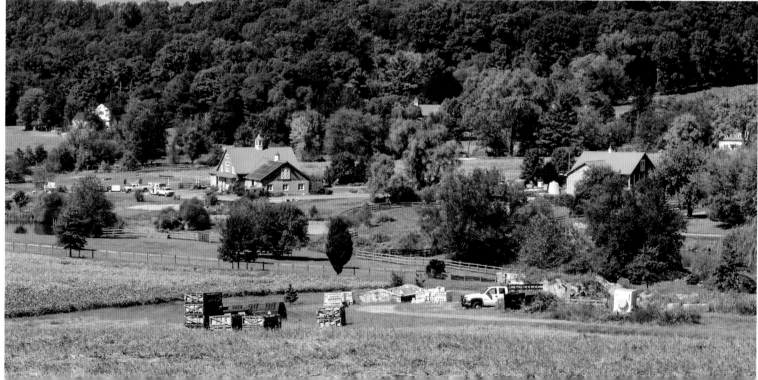

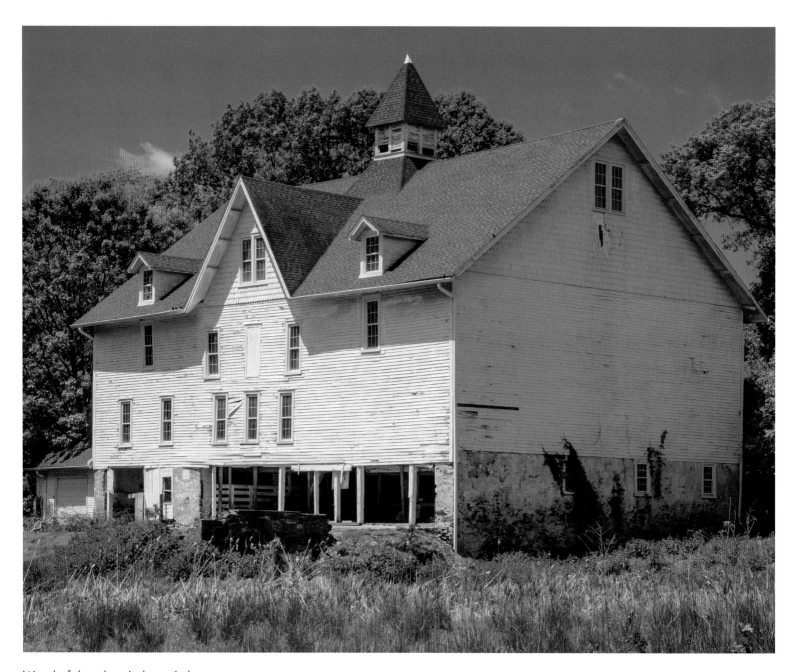

Wonderful and varied scenic barns

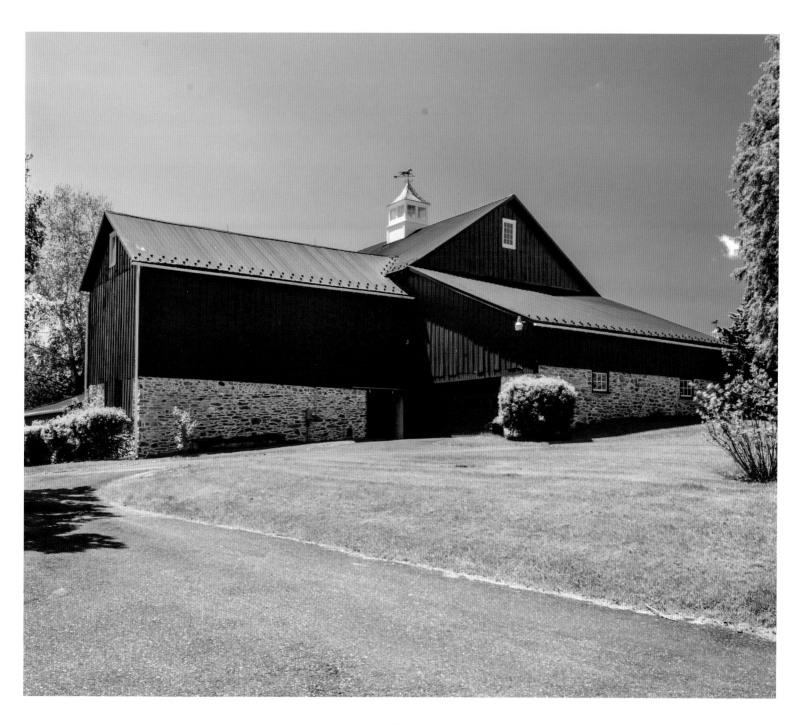

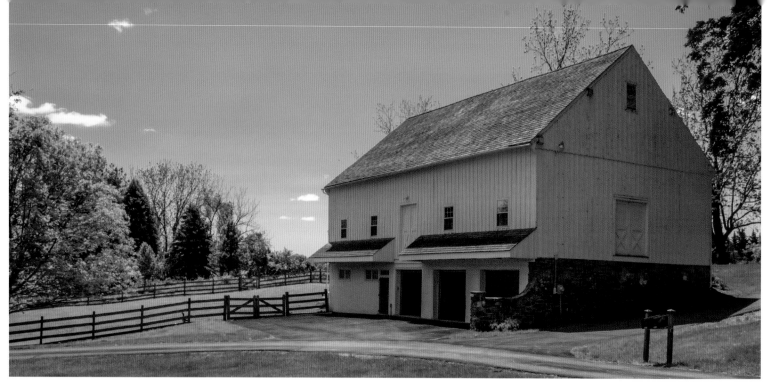
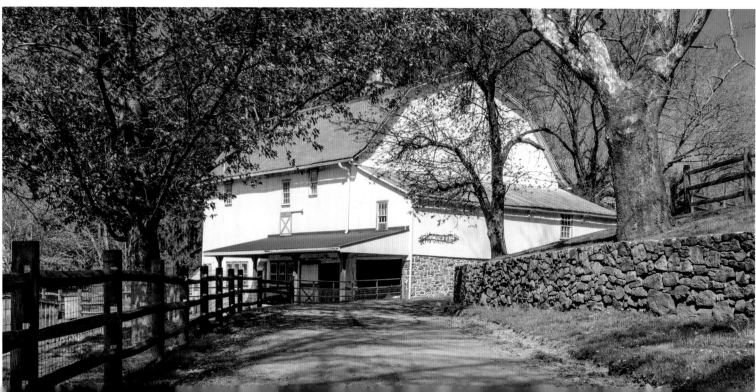

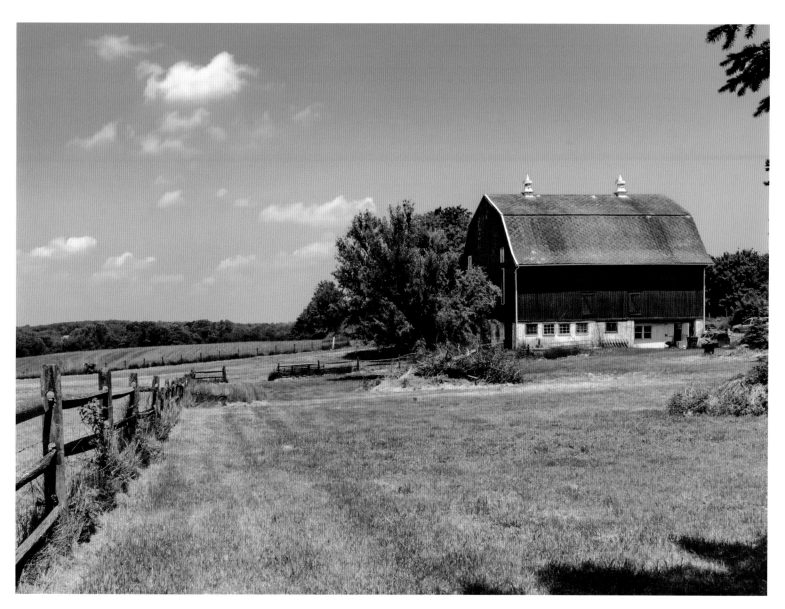

Examples of the Sears and Roebuck Dairy Belle barn with a gambrel roof, sometimes referred to as "Dutch Colonial Barns"

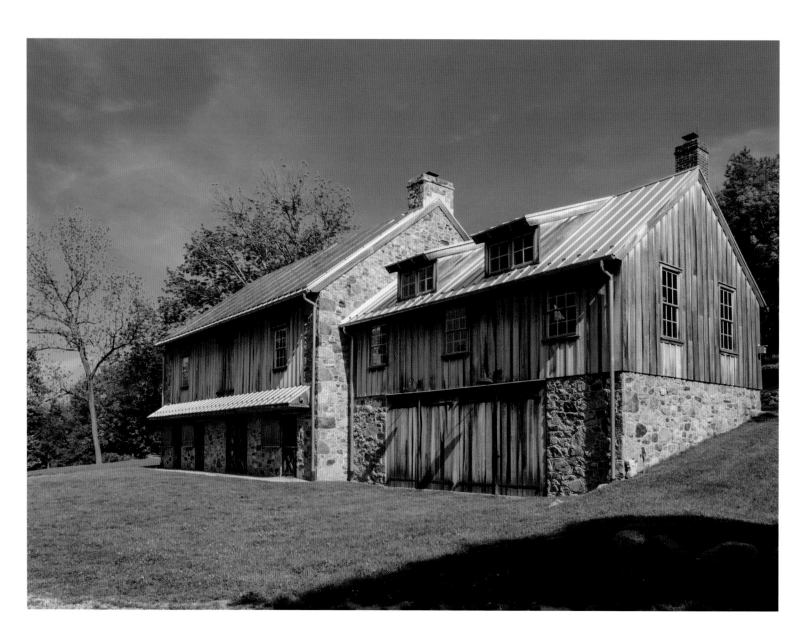

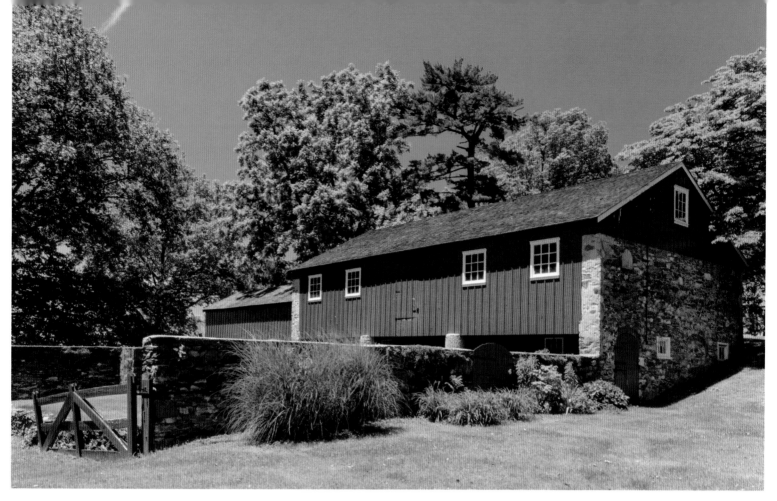

This red bank barn got its name from being built into the side of a hill, allowing access to both levels of the barn from the ground.

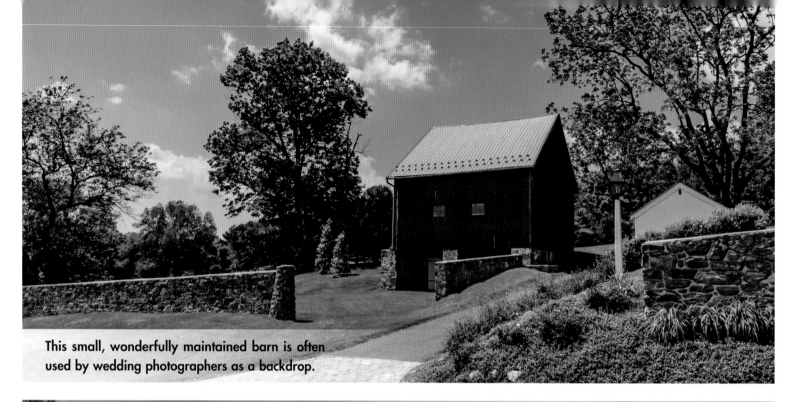

This small, wonderfully maintained barn is often used by wedding photographers as a backdrop.

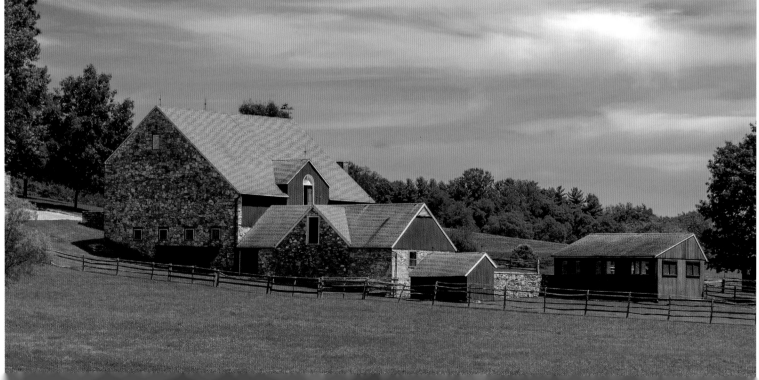

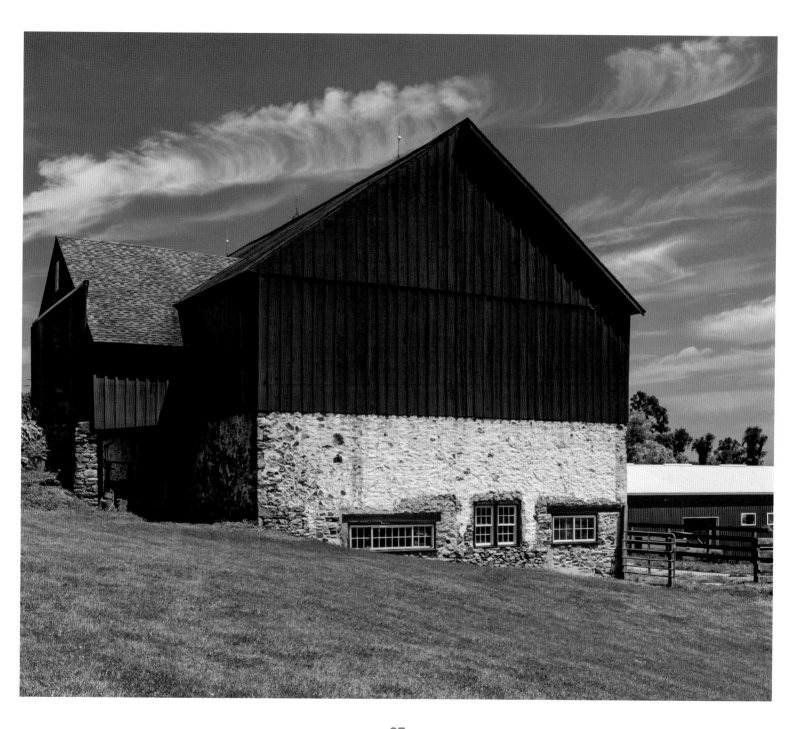

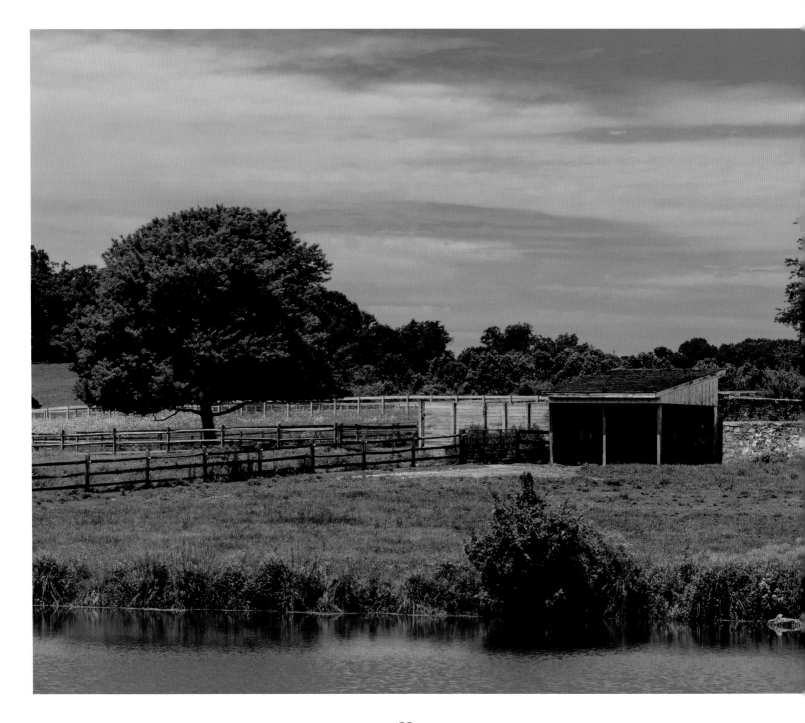

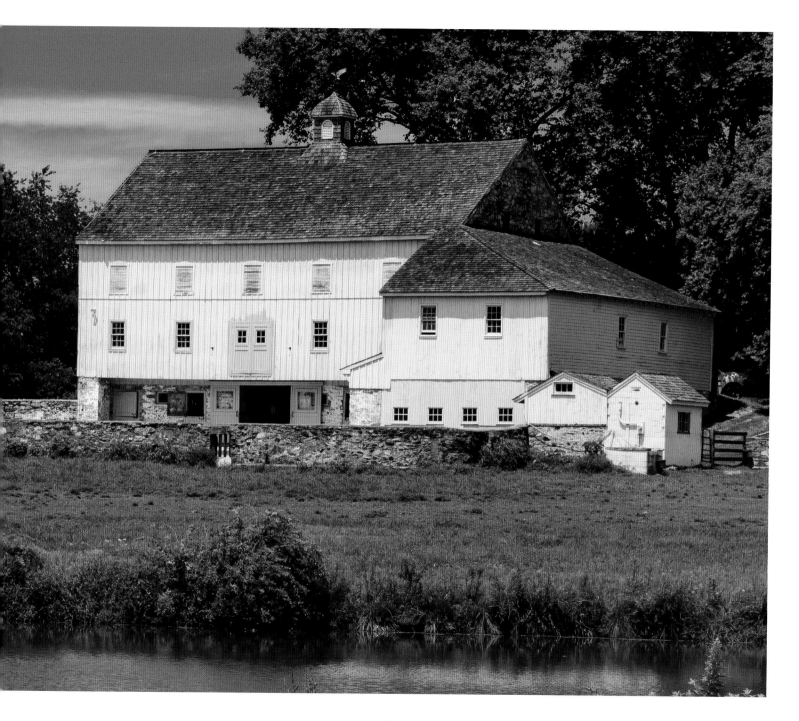

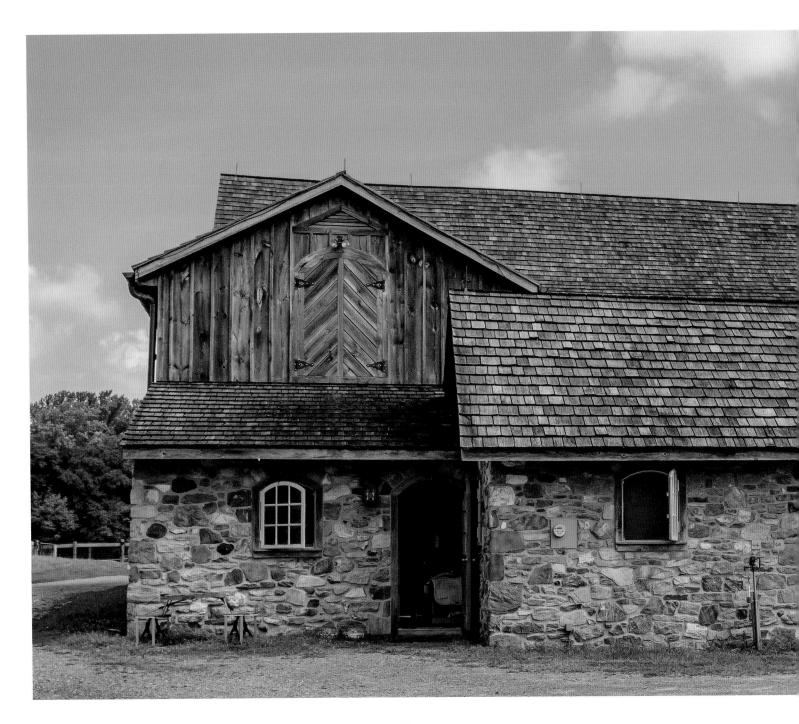

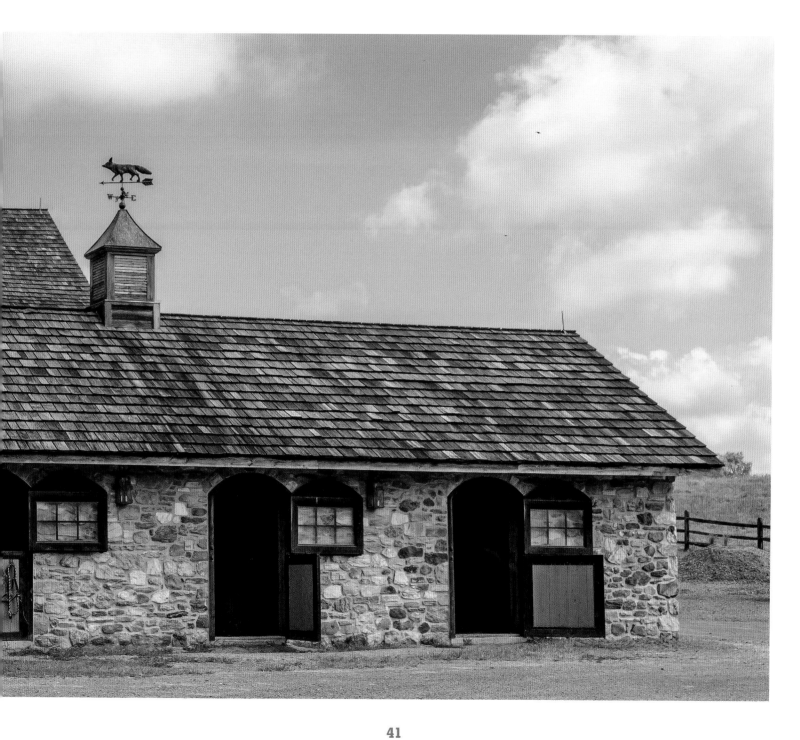

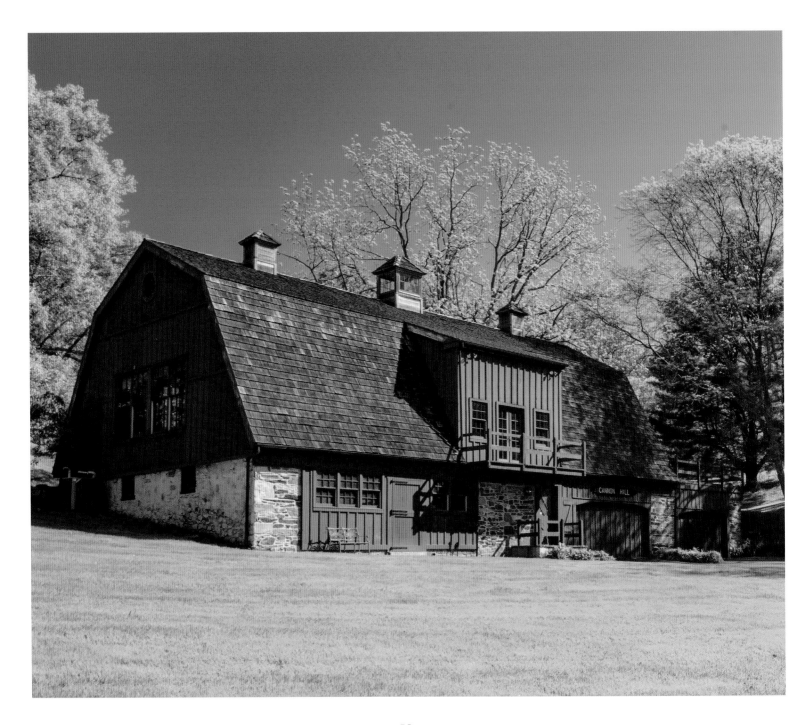

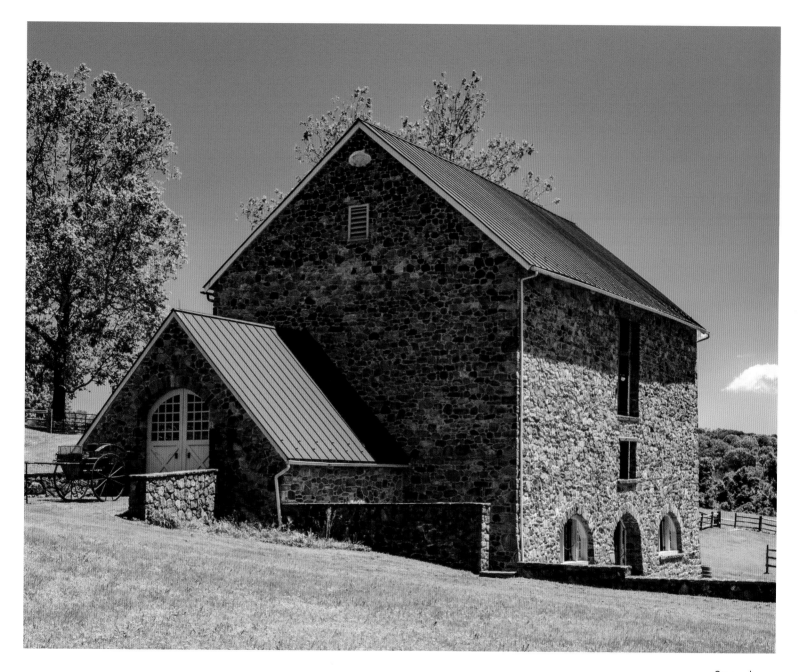

Stone barn

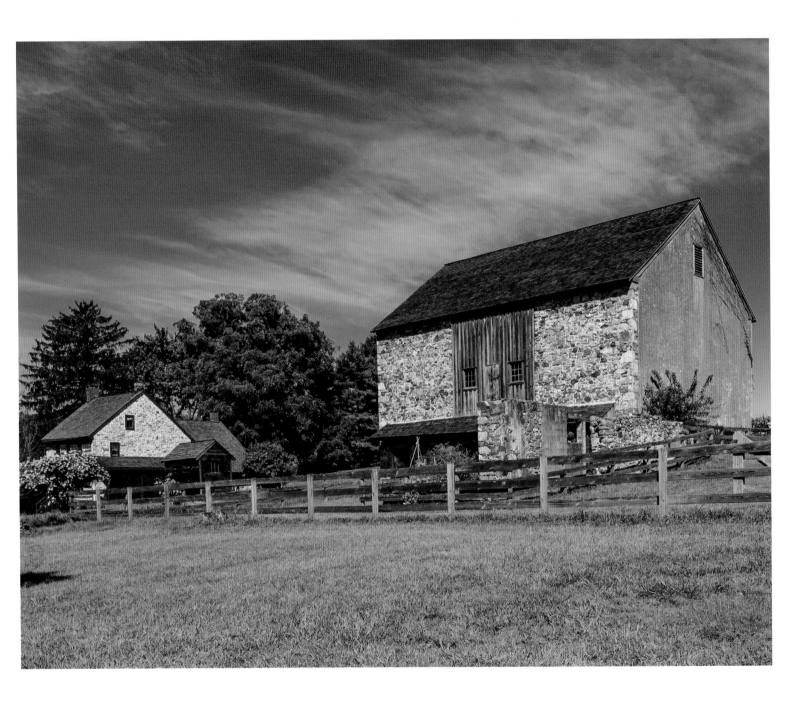

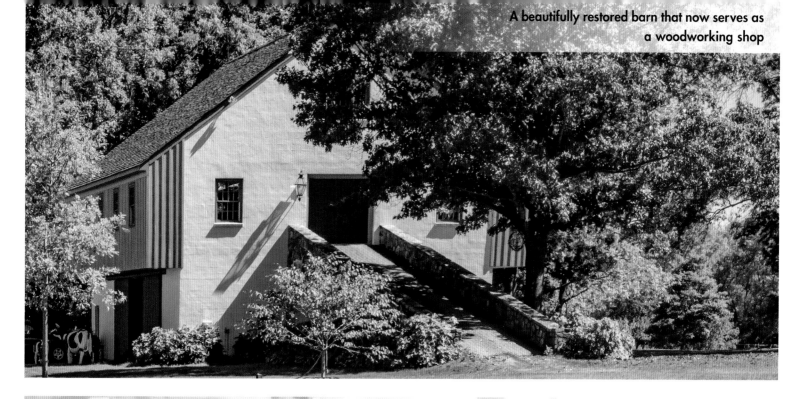

A beautifully restored barn that now serves as a woodworking shop

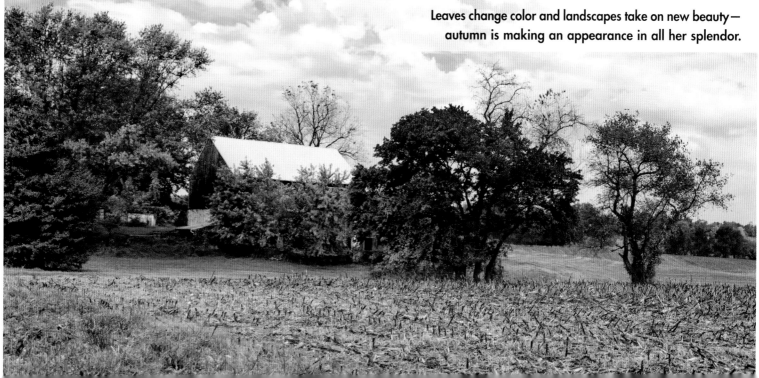

Leaves change color and landscapes take on new beauty—autumn is making an appearance in all her splendor.

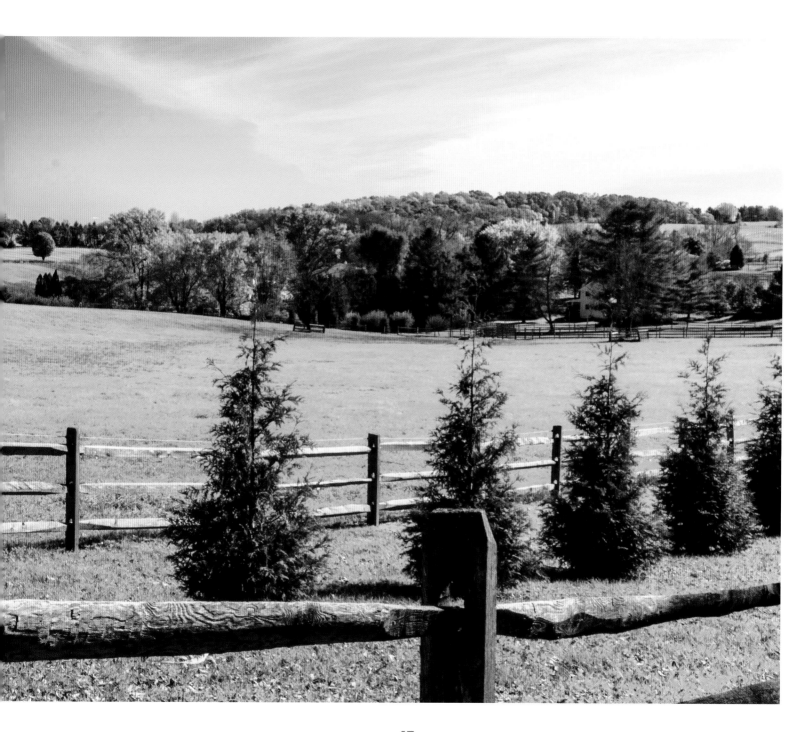

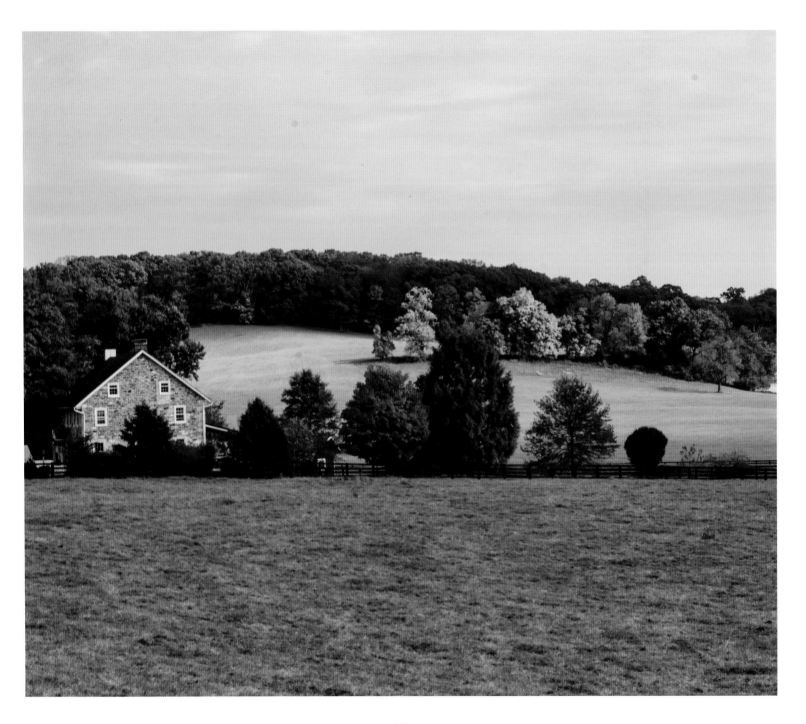

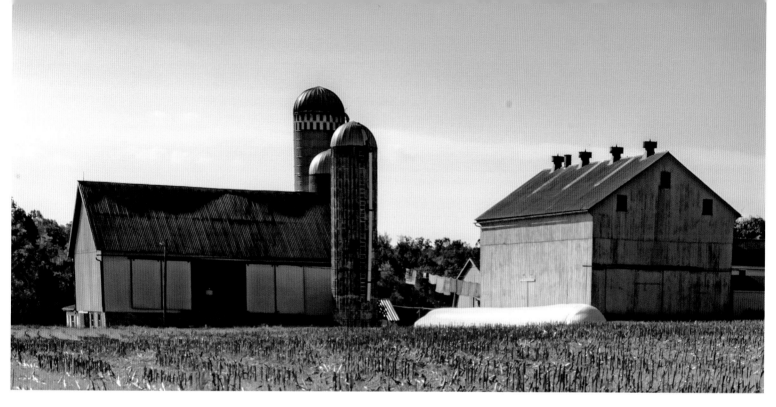

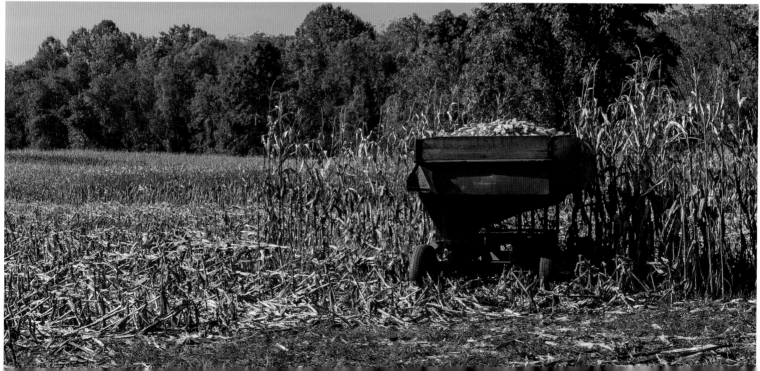

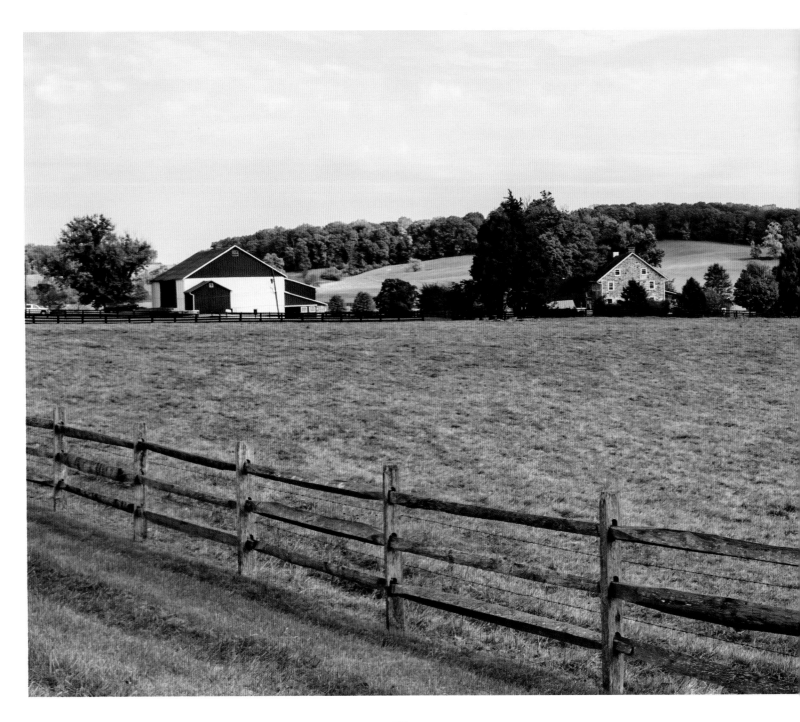

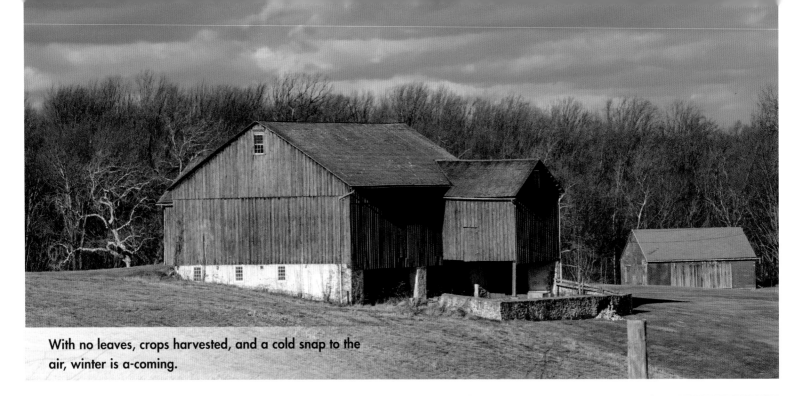

With no leaves, crops harvested, and a cold snap to the air, winter is a-coming.

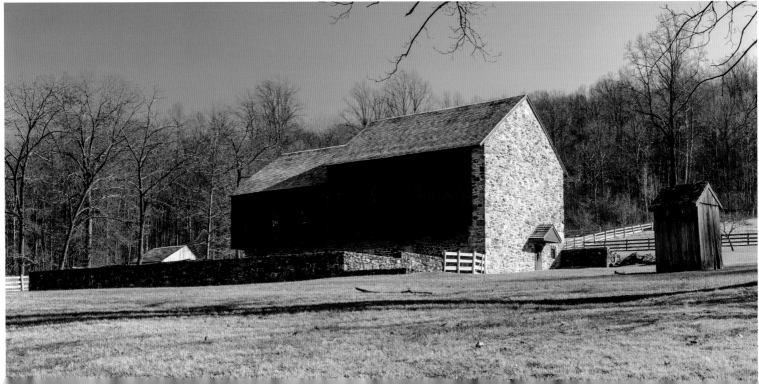

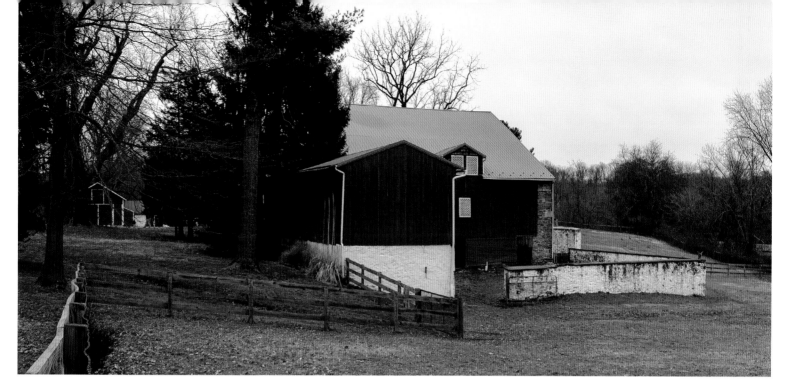
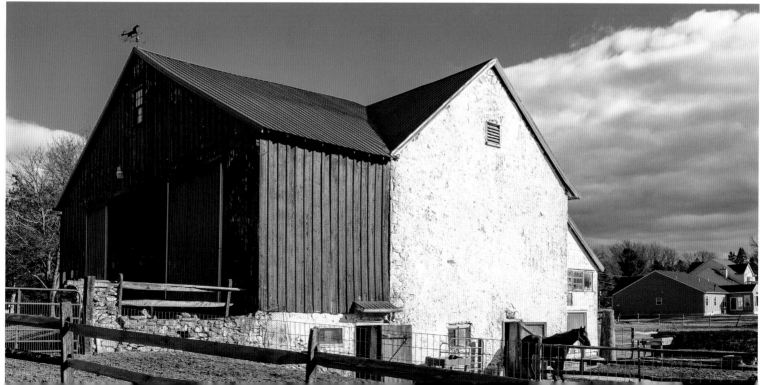

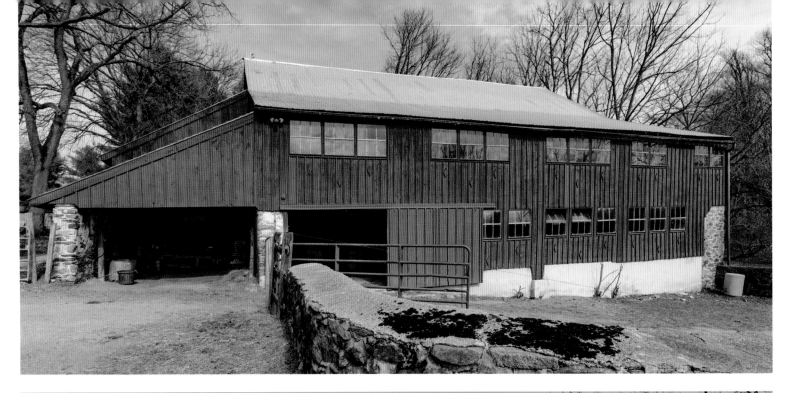
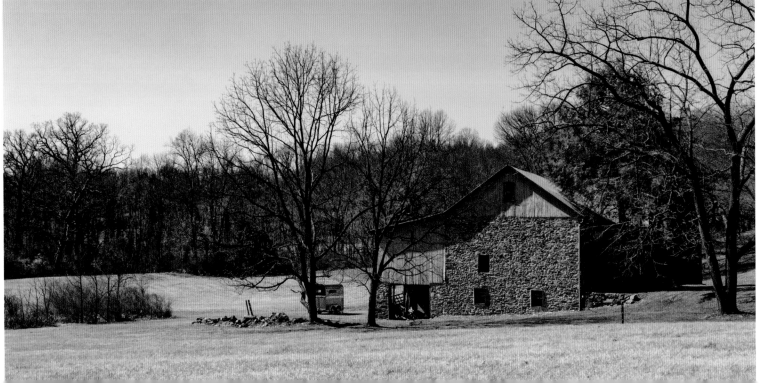

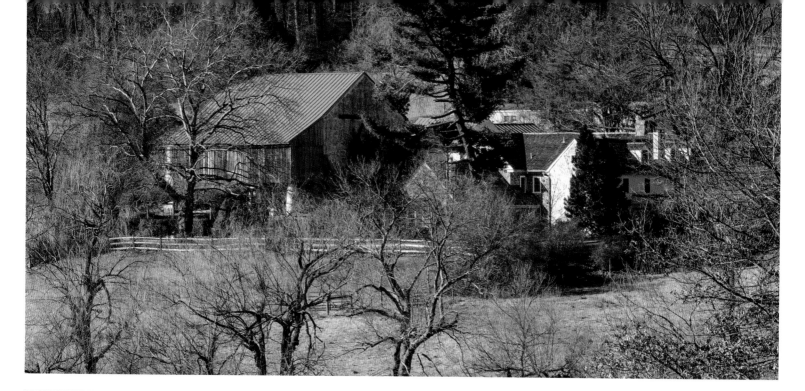

White fluffy clouds, blue skies, and a little snow
make for a lovely day.

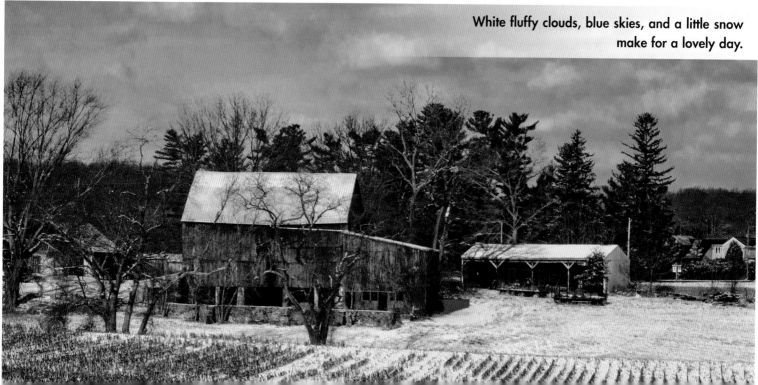

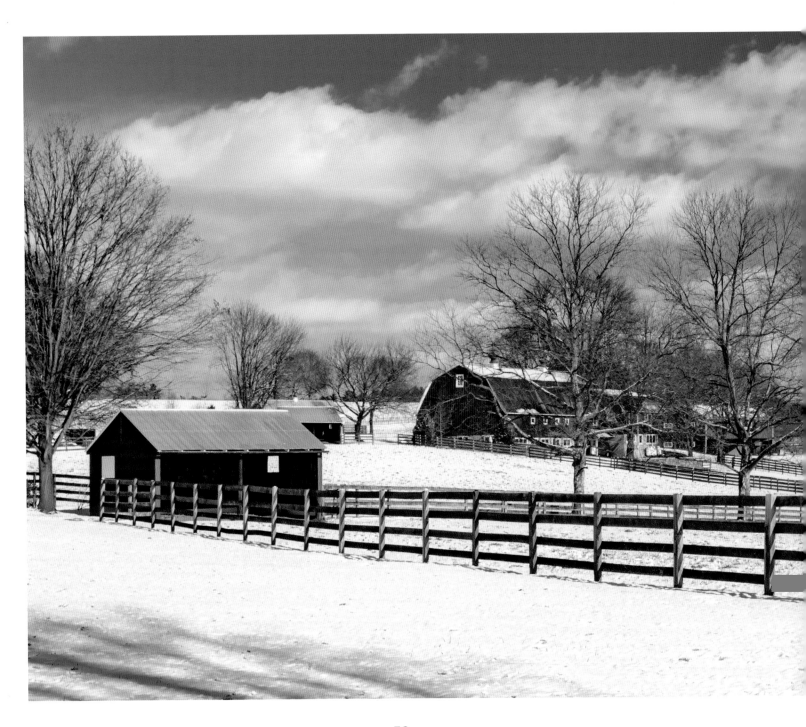

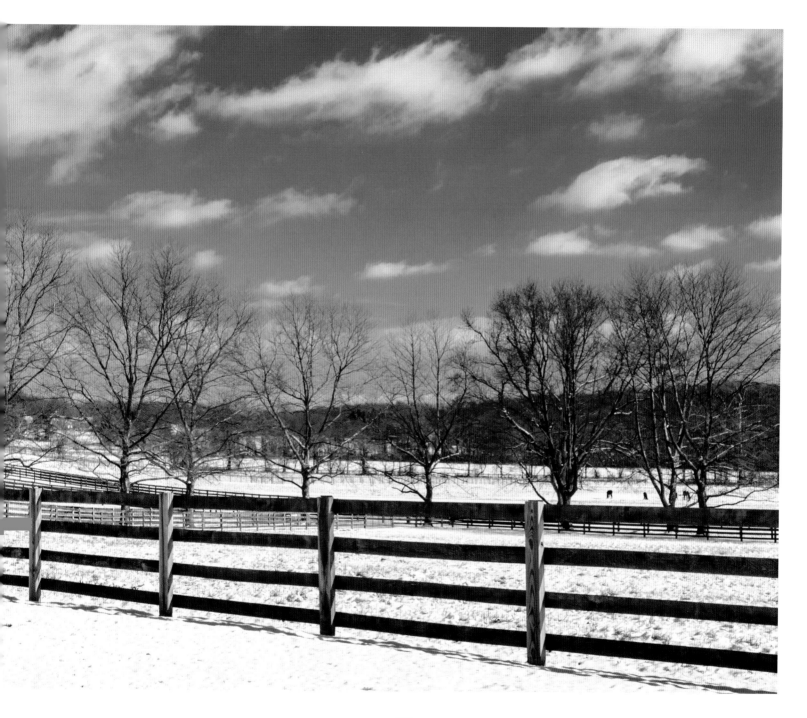

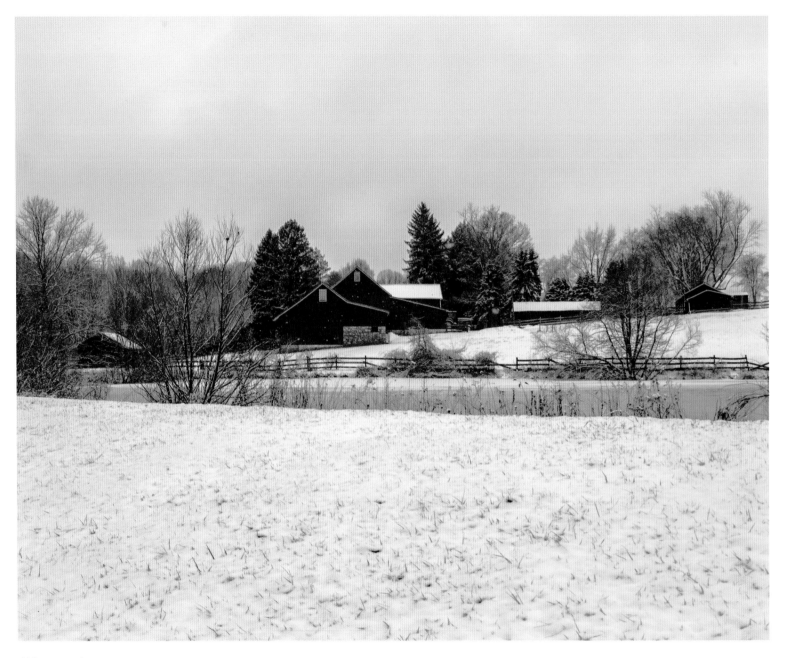

Winter arrives.

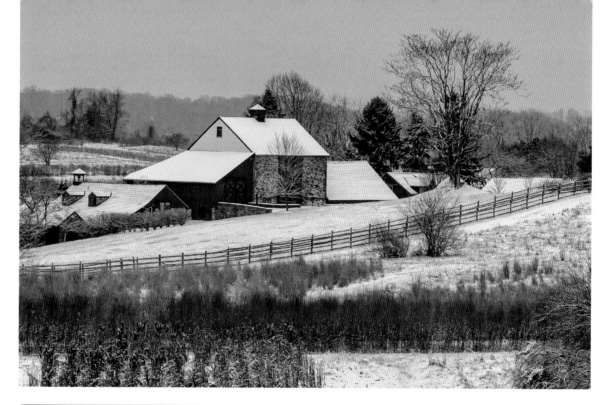

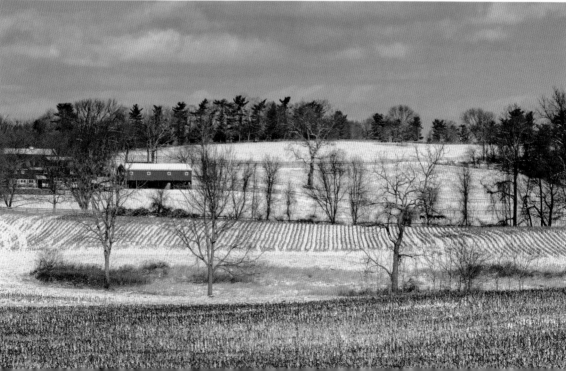

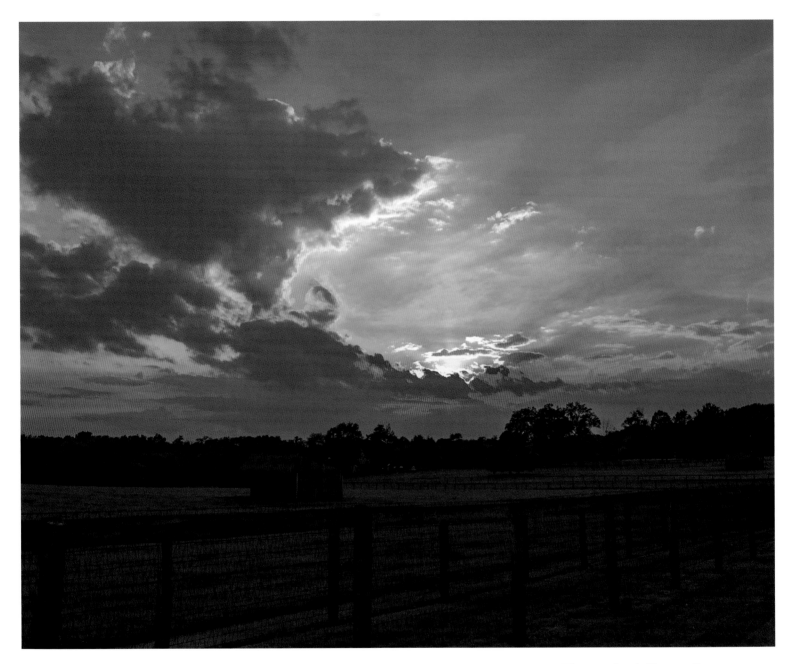

The magic of Chester County sunsets

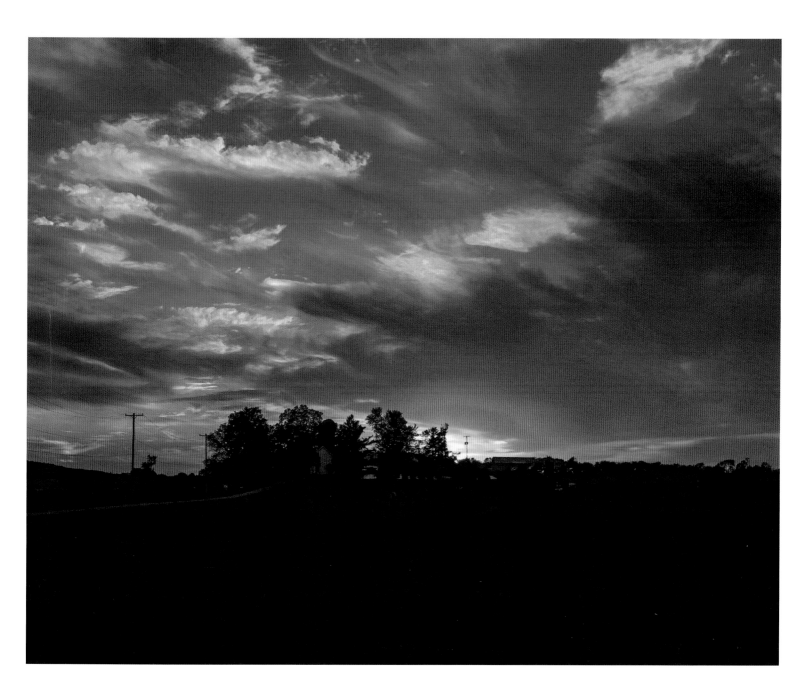

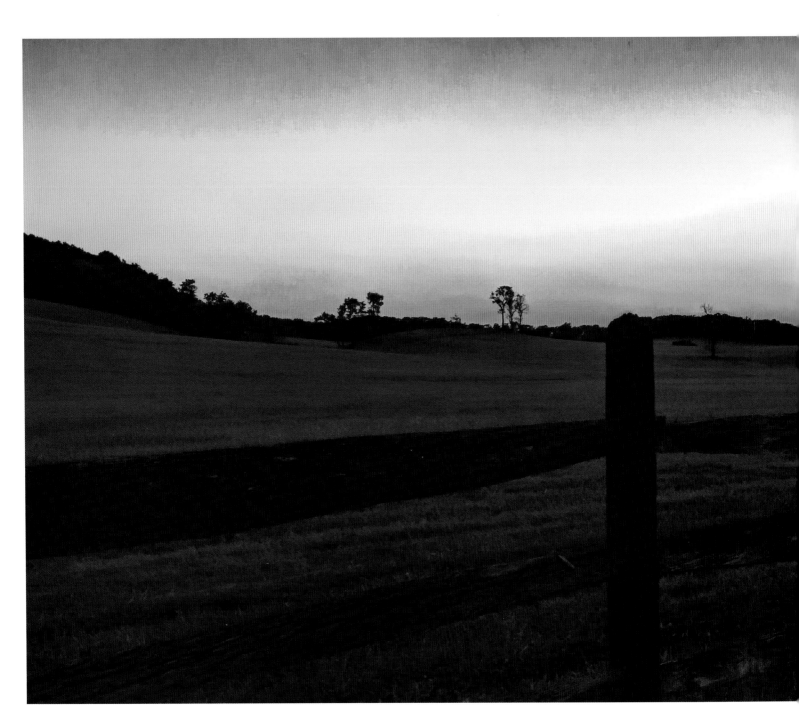

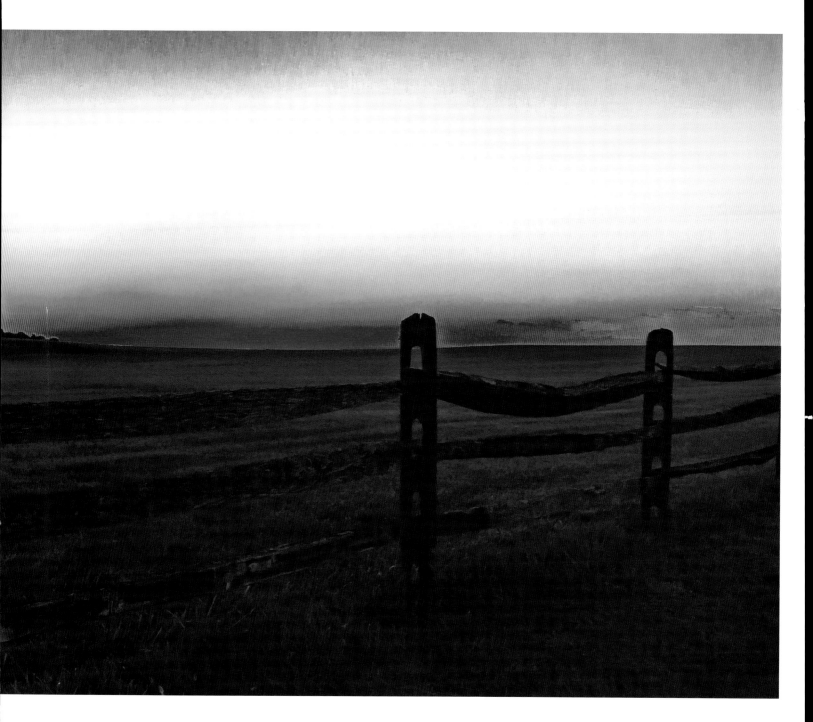

CHAPTER TWO
THOSE THAT LIVE THERE

"I am still under the impression that there is nothing alive quite so beautiful as a horse."

—John Galsworthy

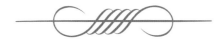

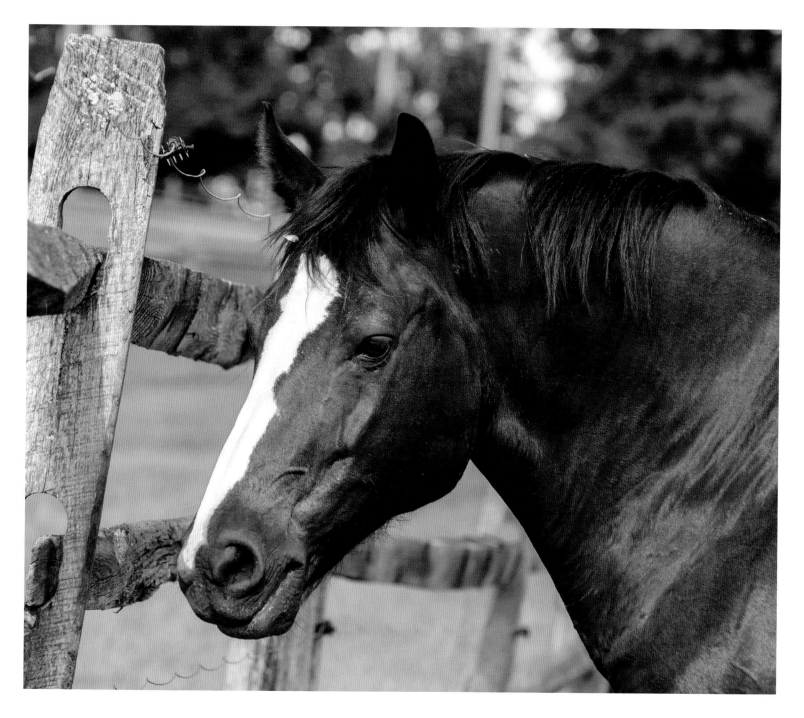

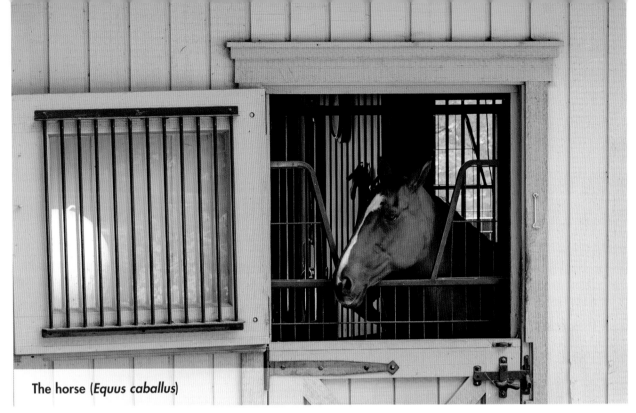

The horse (*Equus caballus*)

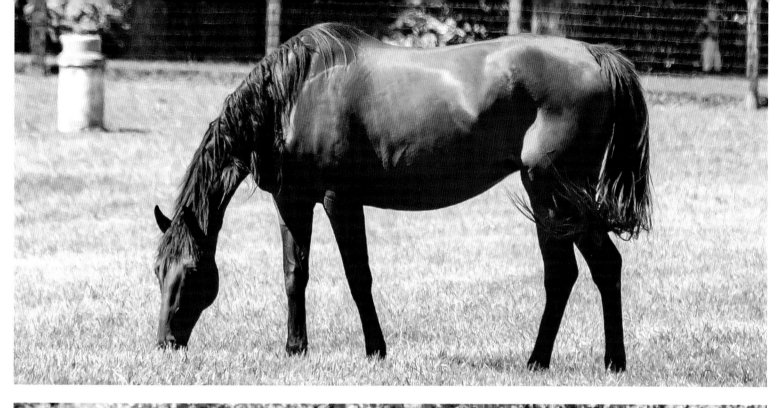
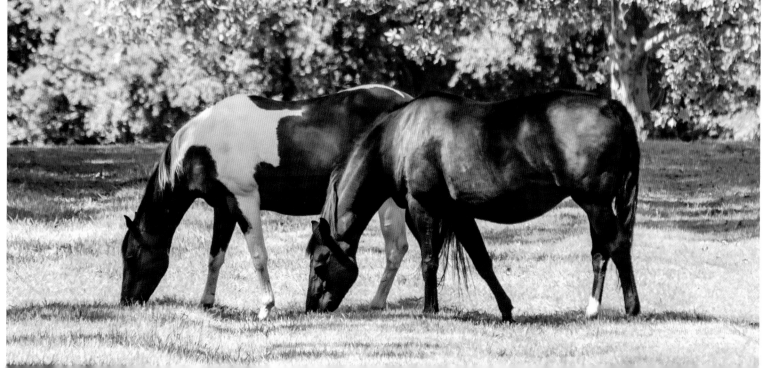

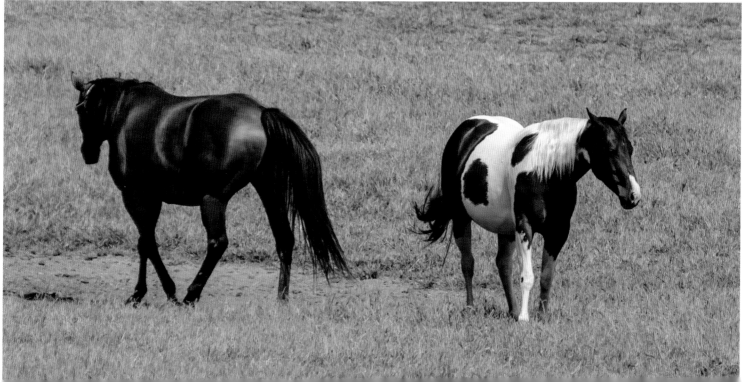

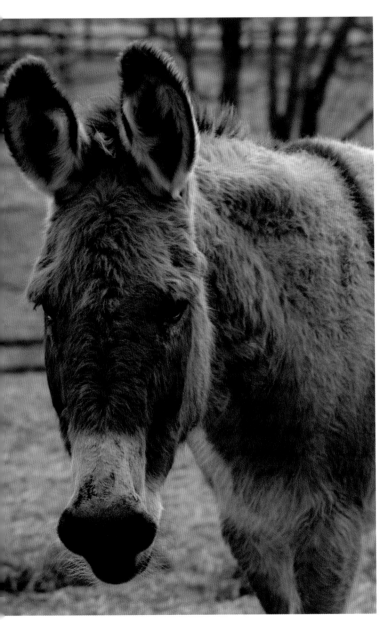
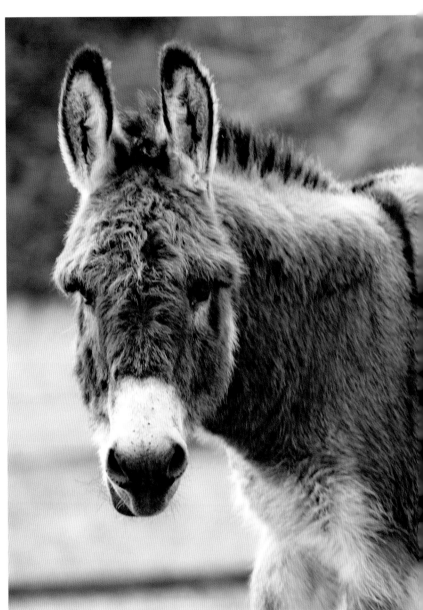

The donkey (*Equus asinus*)

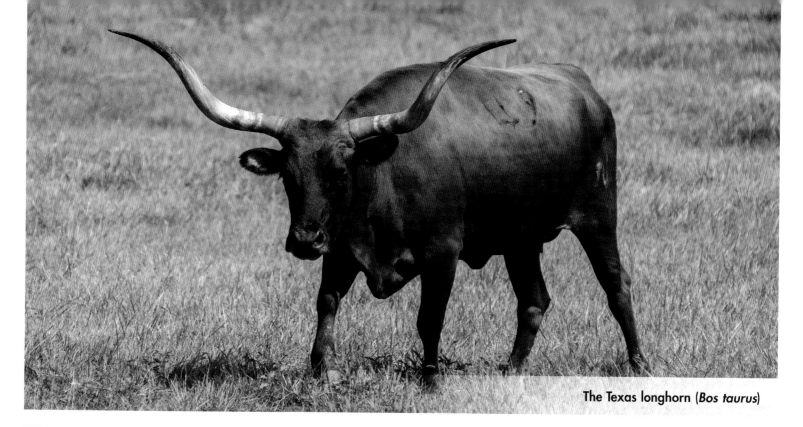

The Texas longhorn (*Bos taurus*)

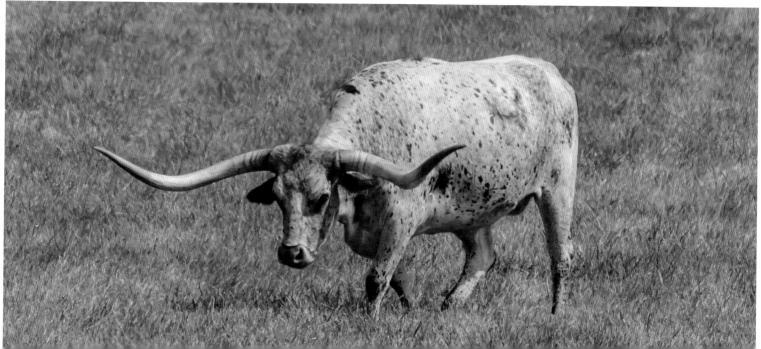

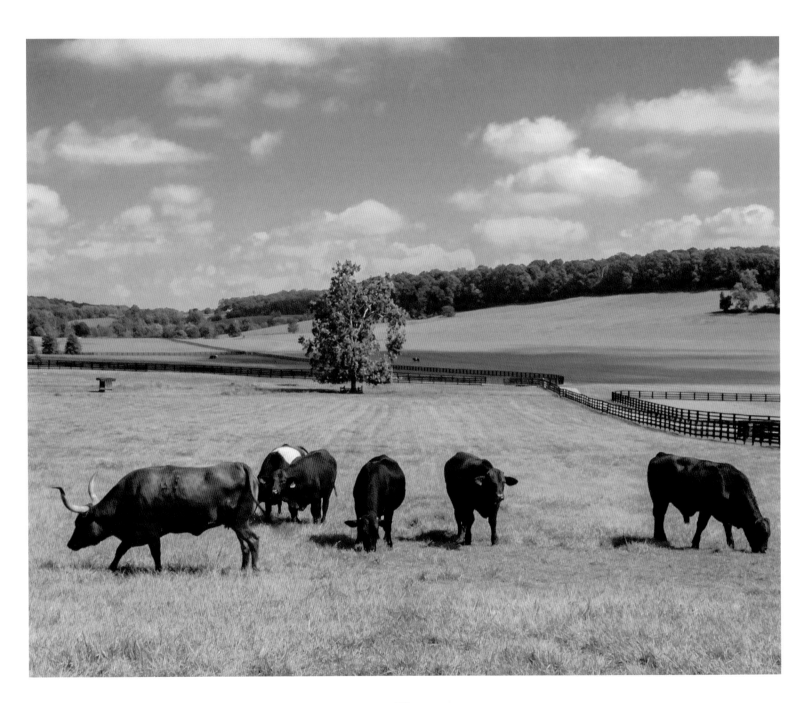

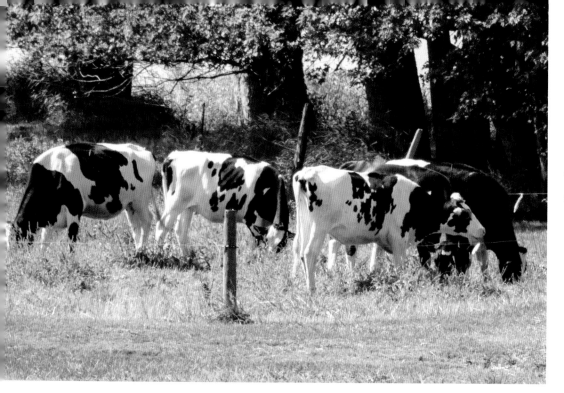

The Holstein, found on many farms in Chester County (*Bos taurus*)

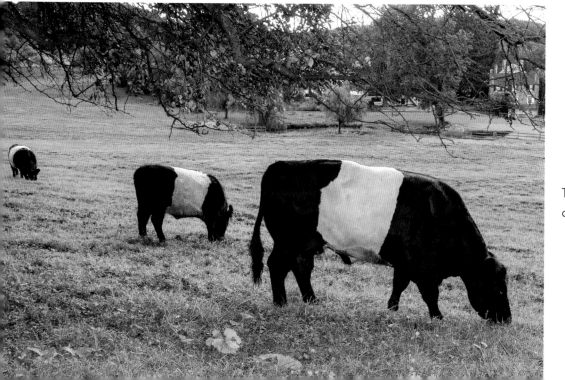

The Belted Galloway, more commonly called "Belties" (*Bos taurus*)

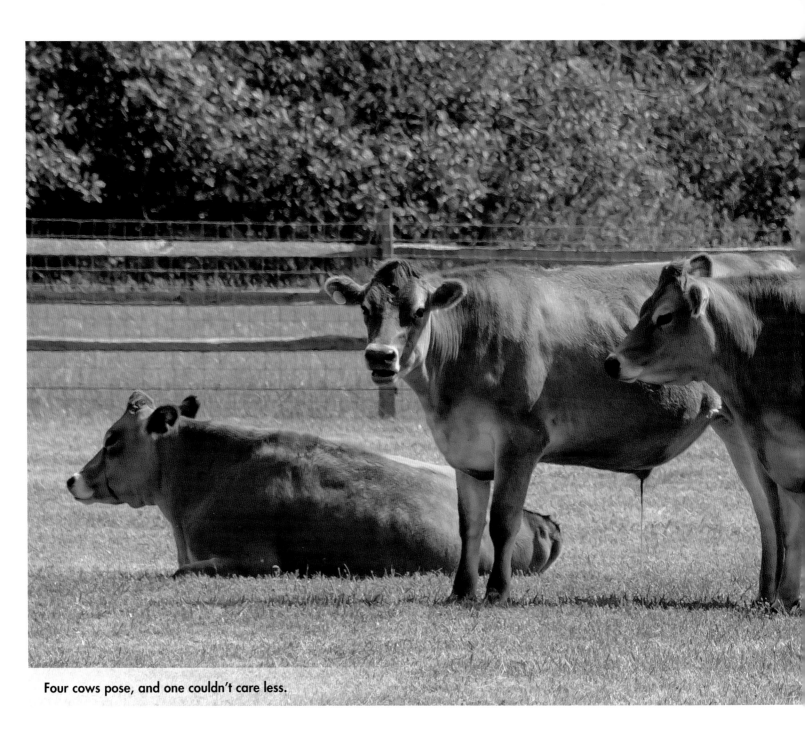

Four cows pose, and one couldn't care less.

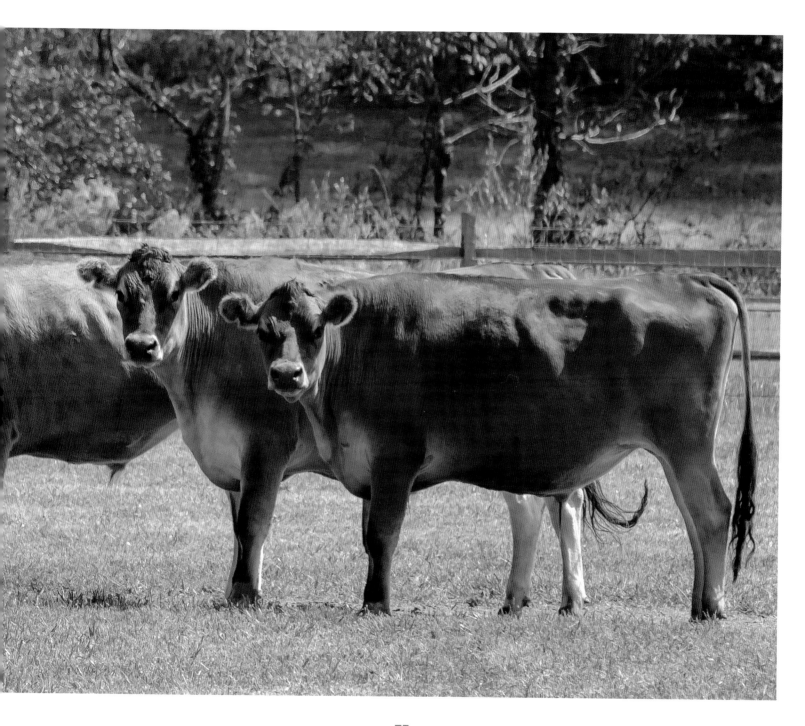

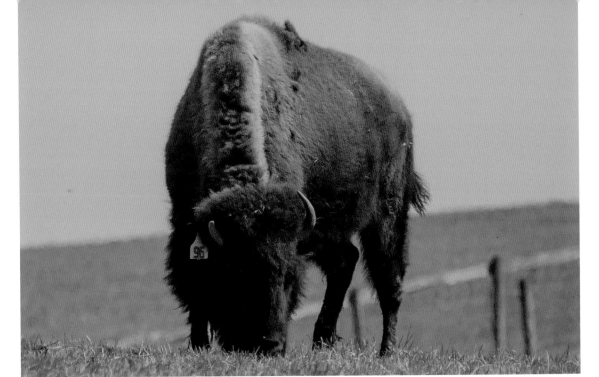

The American bison (*Bison bison*)

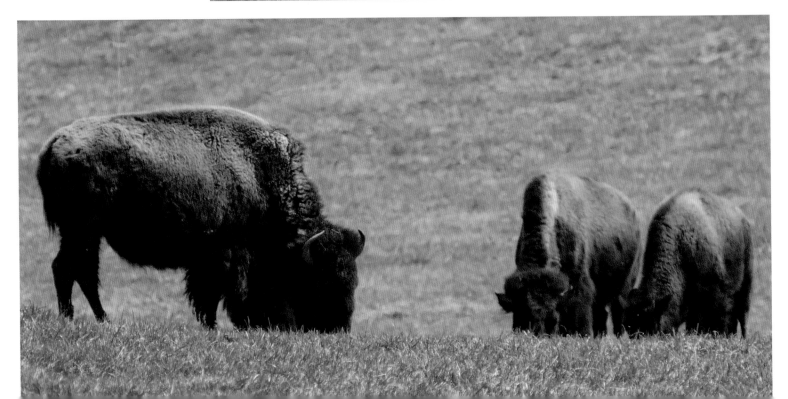

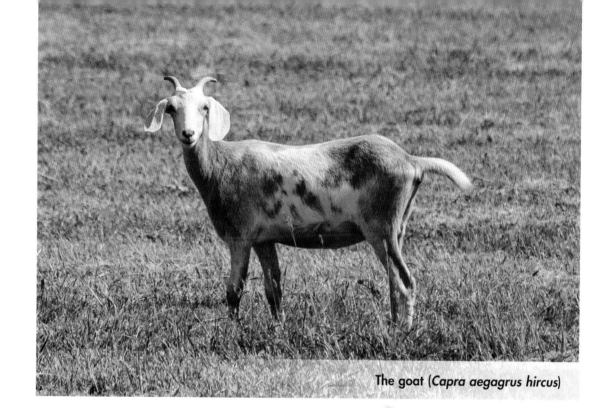

The goat (*Capra aegagrus hircus*)

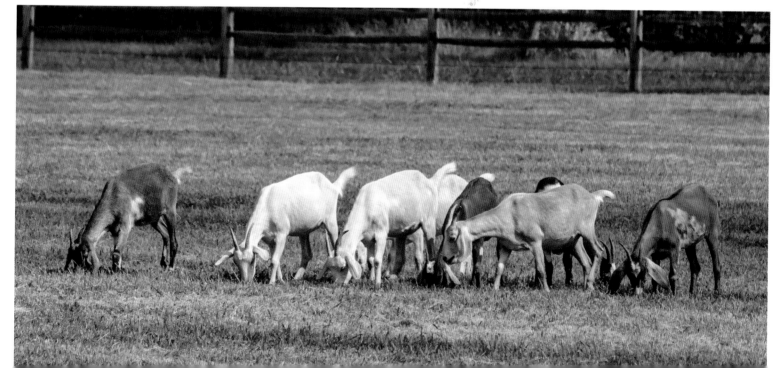

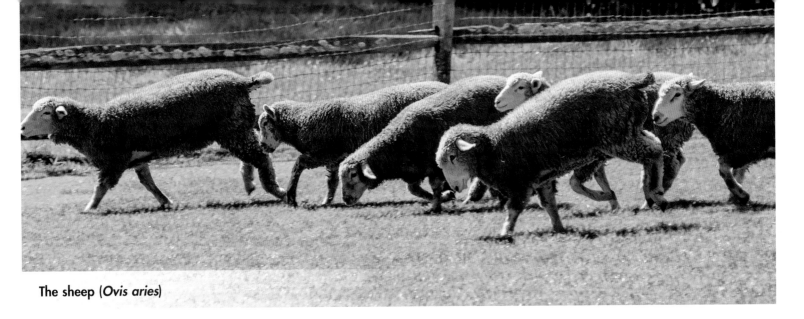

The sheep (*Ovis aries*)

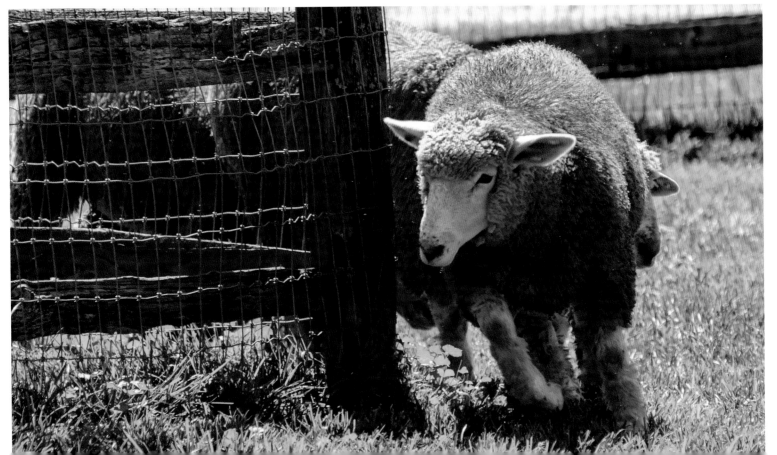

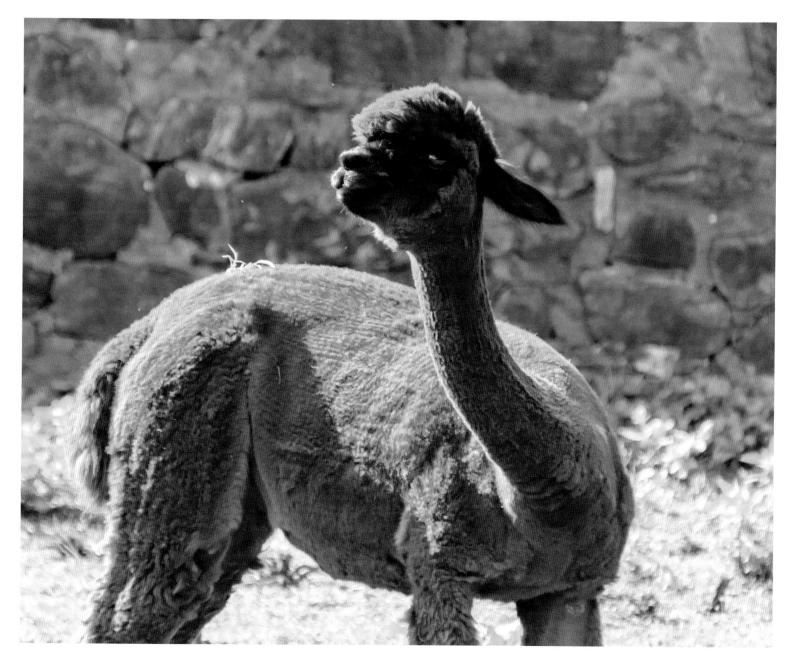

The alpaca (*Vicugna pacos*)

The emu (*Dromaius novaehollandiae*)

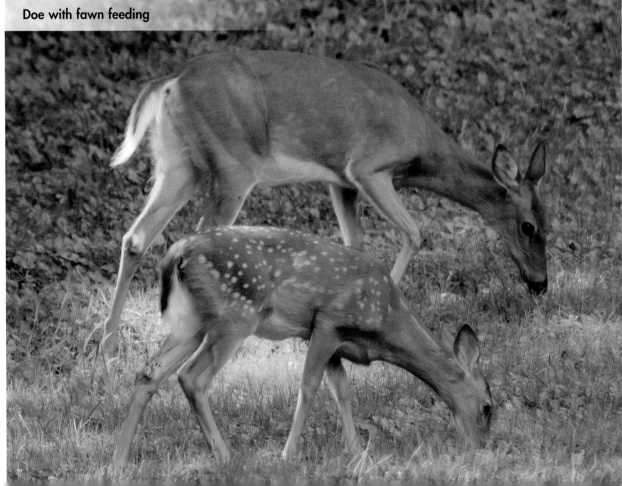

Doe with fawn feeding

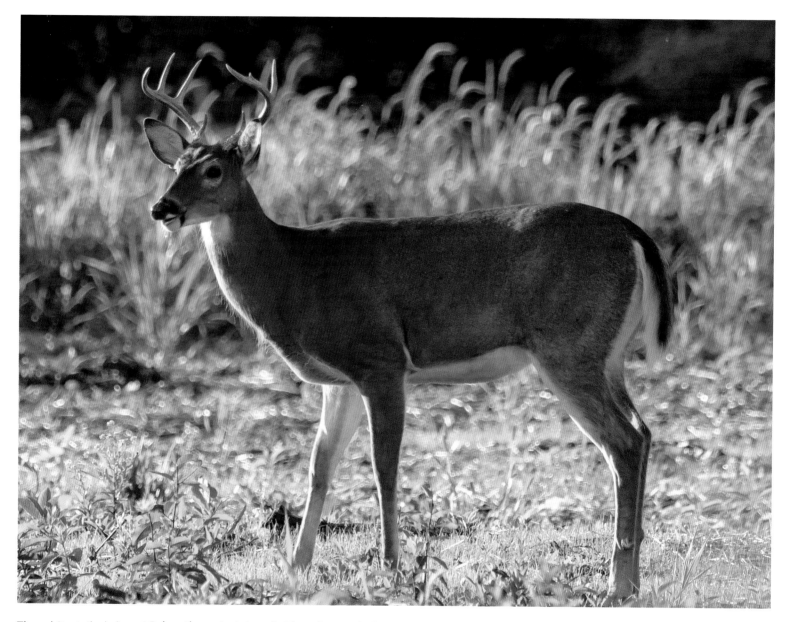

The white-tailed deer (*Odocoileus virginianus*). The white-tailed deer is common all over Chester County, especially during sunrise and early evening into sunsets.

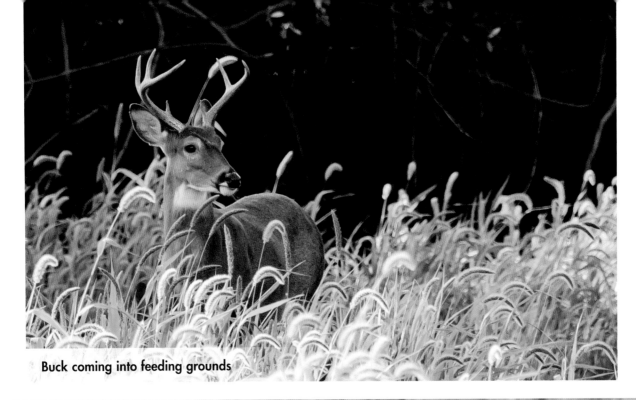

Buck coming into feeding grounds

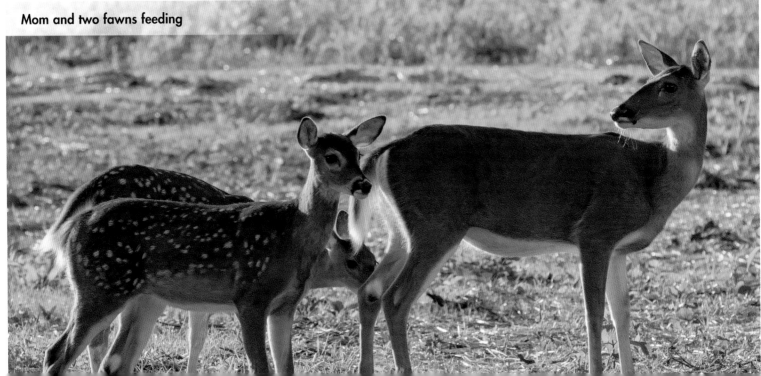

Mom and two fawns feeding

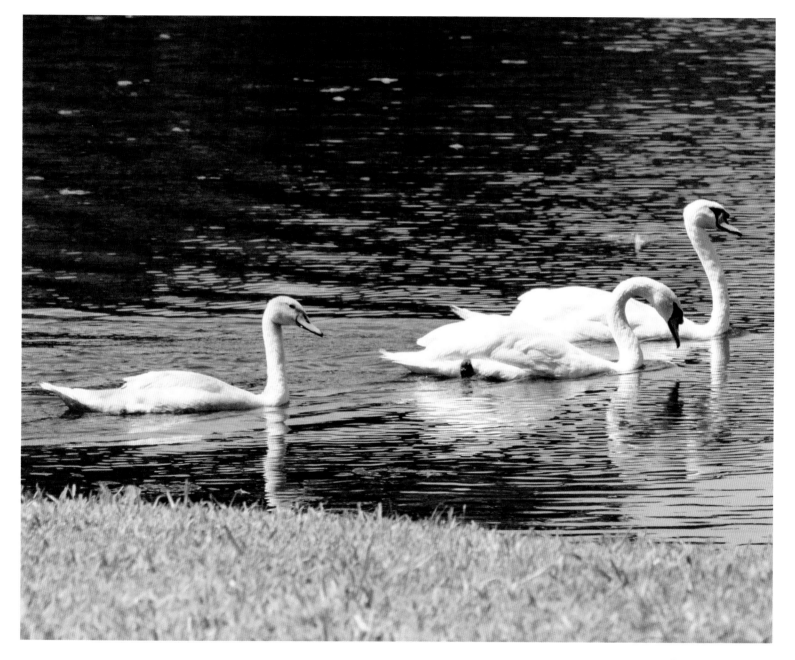

The swan (*Cygnini*)

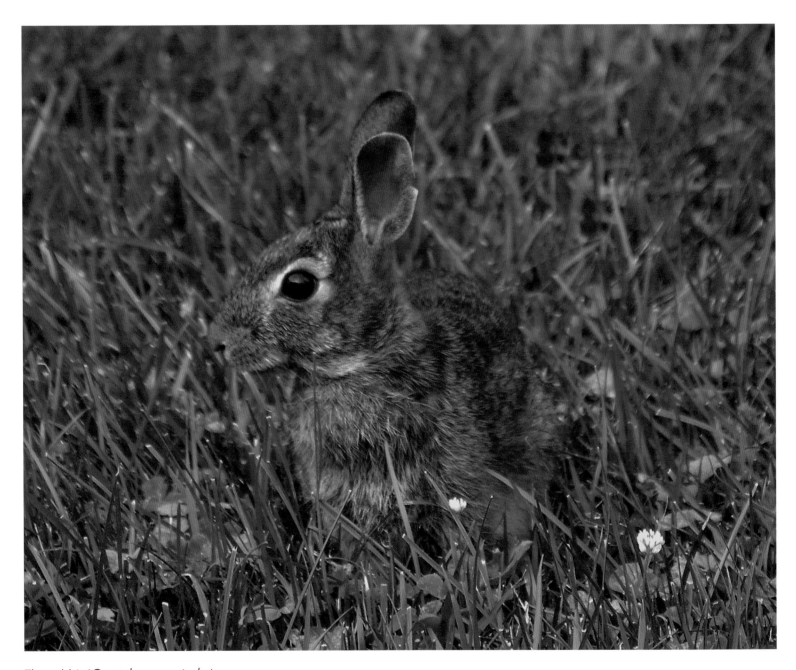

The rabbit (*Oryctolagus cuniculus*)

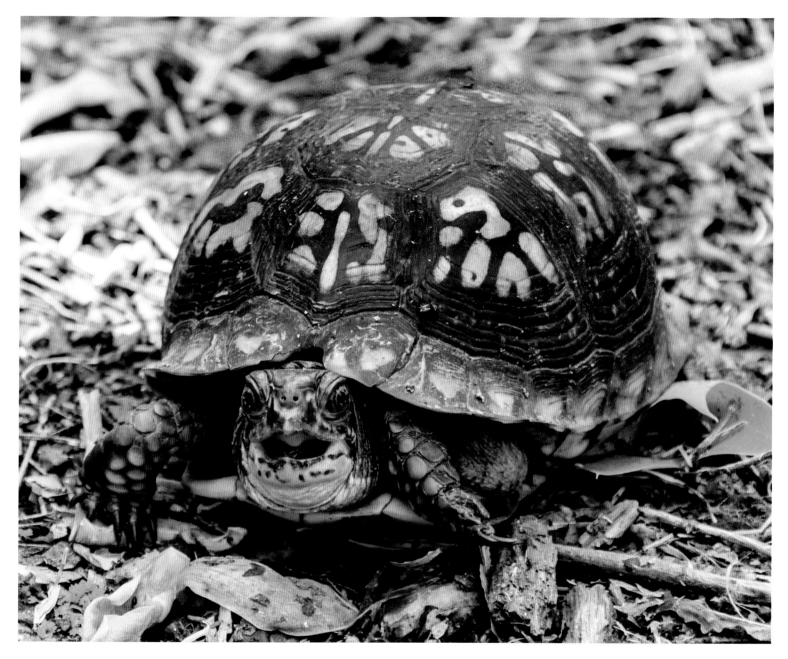

The turtle (*Testudines*)

The Canada goose (*Branta canadensis*)

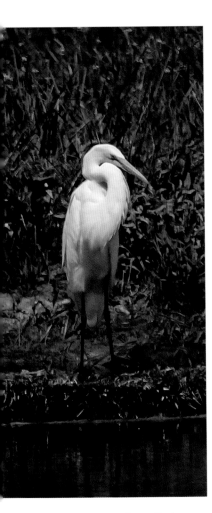

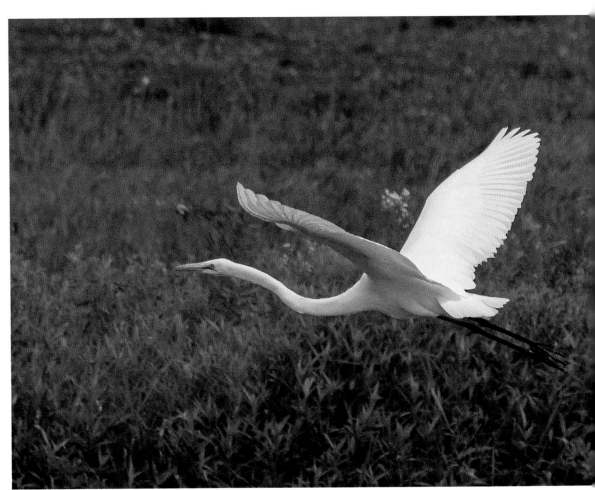

The great egret (*Ardea alba*)

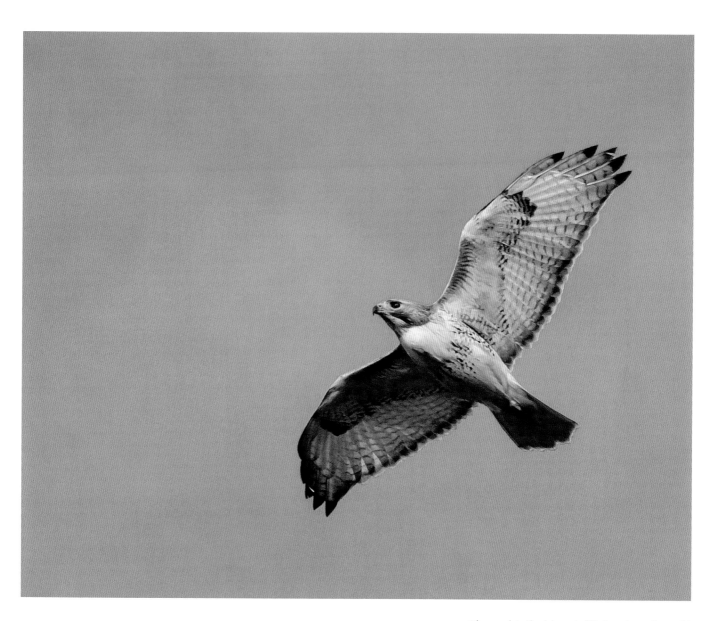

The red-tailed hawk (*Buteo jamaicensis*)

The turkey vulture (*Cathartes aura*)

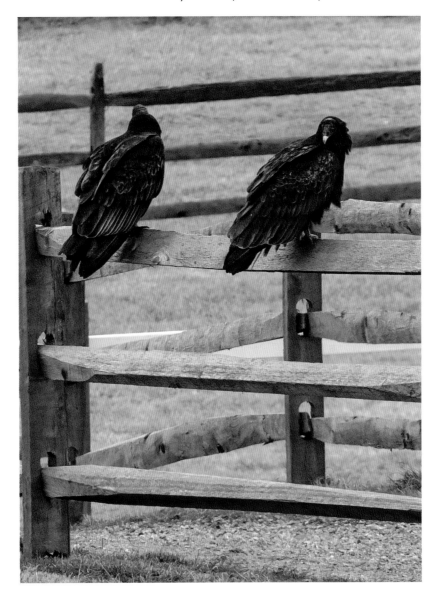

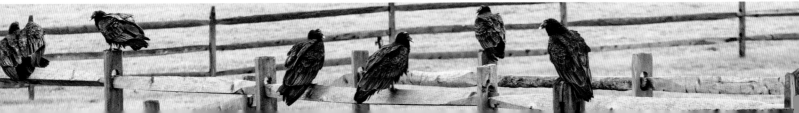

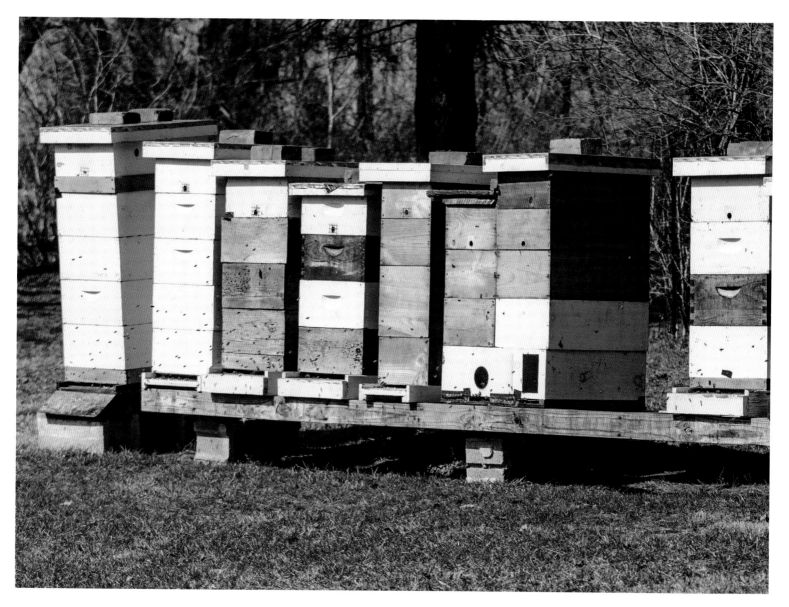

Beehives for making honey can be found on many farms in Chester County.

CHAPTER THREE
TOOLS OF THE TRADE

"No hour of life is lost that is spent in a saddle."

—Winston Churchill

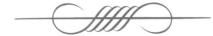

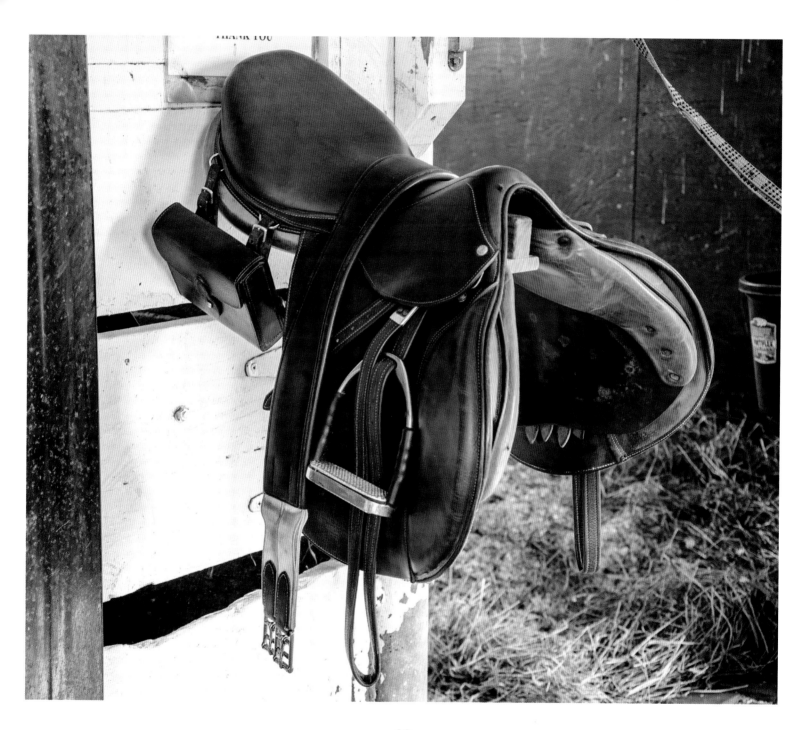

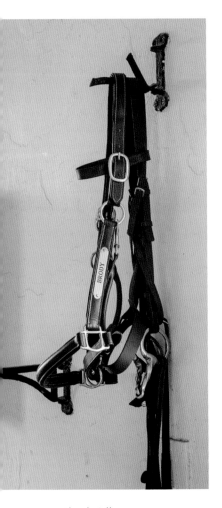

The bridle

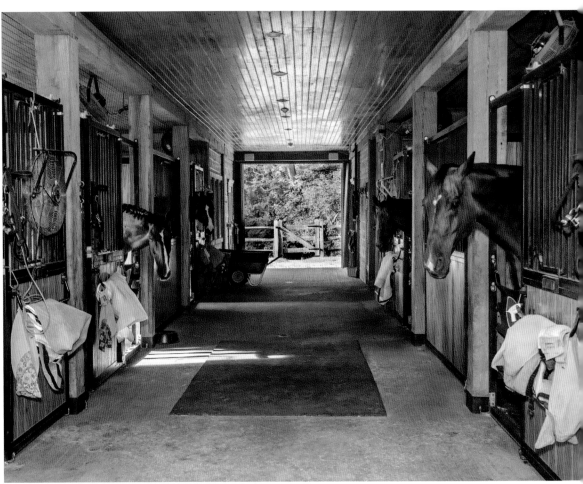

A four-horse welcome into their home

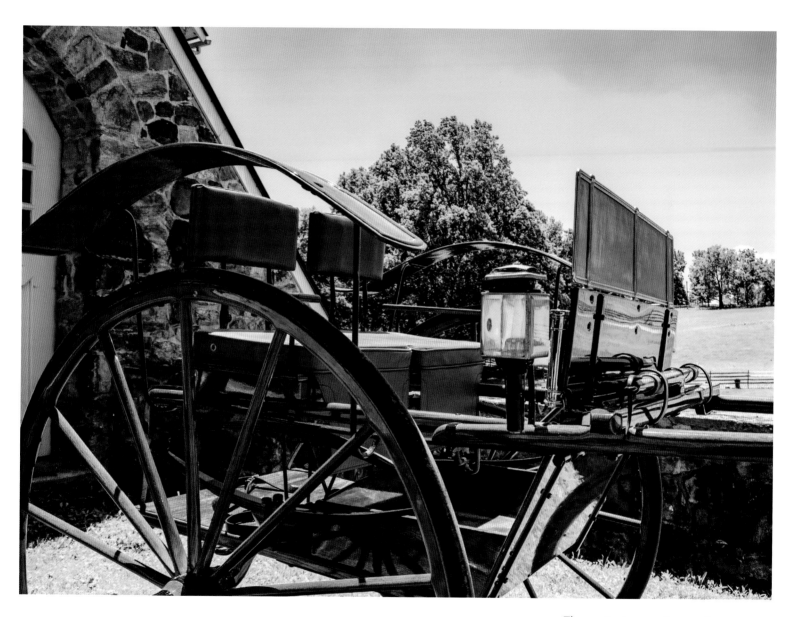

The cart—two seats, one horsepower

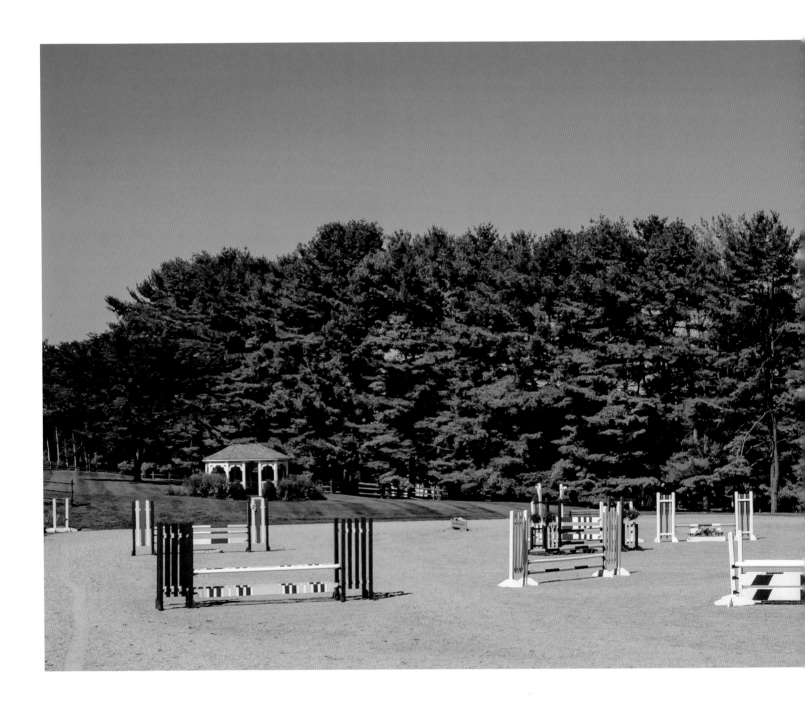

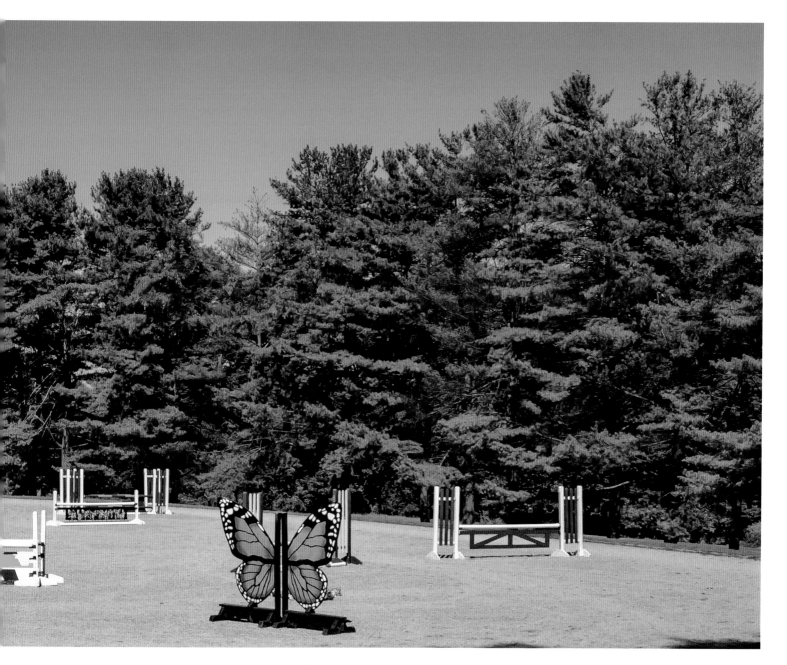

Equestrian training facilities such as this are found on many horse farms throughout Chester County.

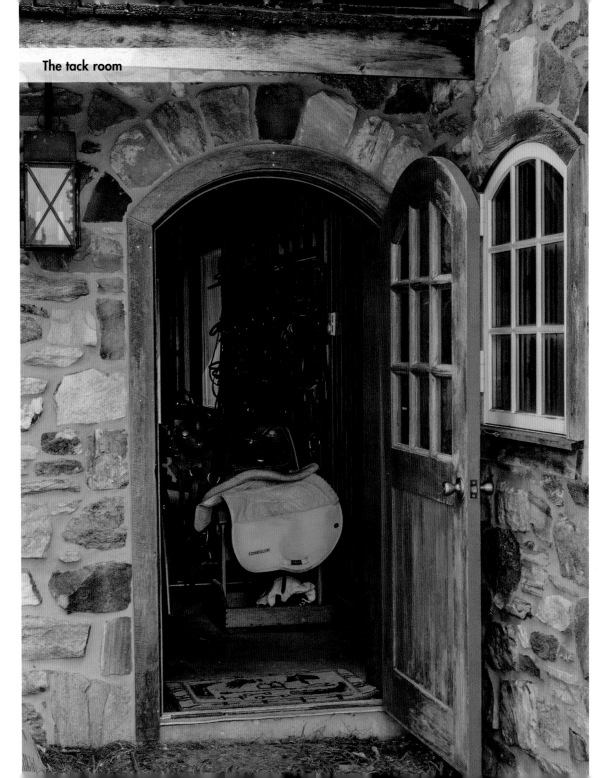

Tractor & silo

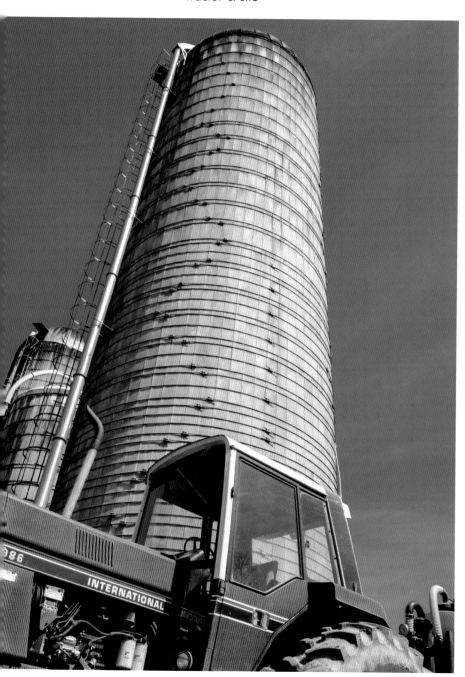

Tractor & combine

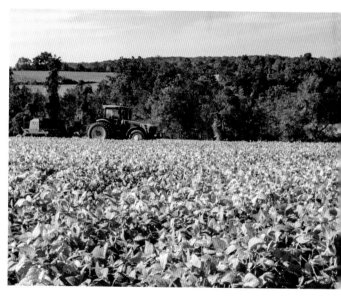

CHAPTER FOUR
ROLLING HILLS

"Nature is a mutable cloud which is always and never the same."

—Ralph Waldo Emerson

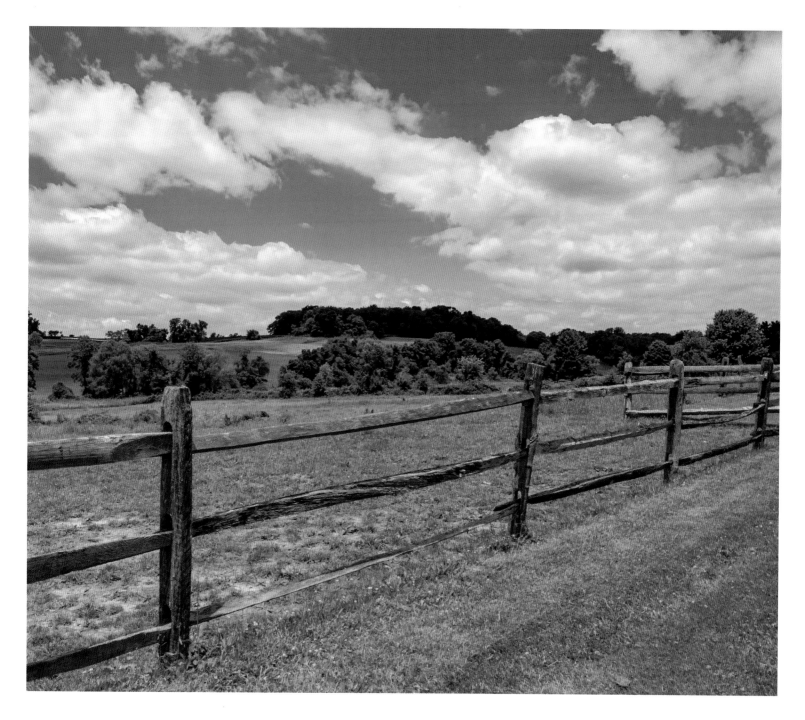

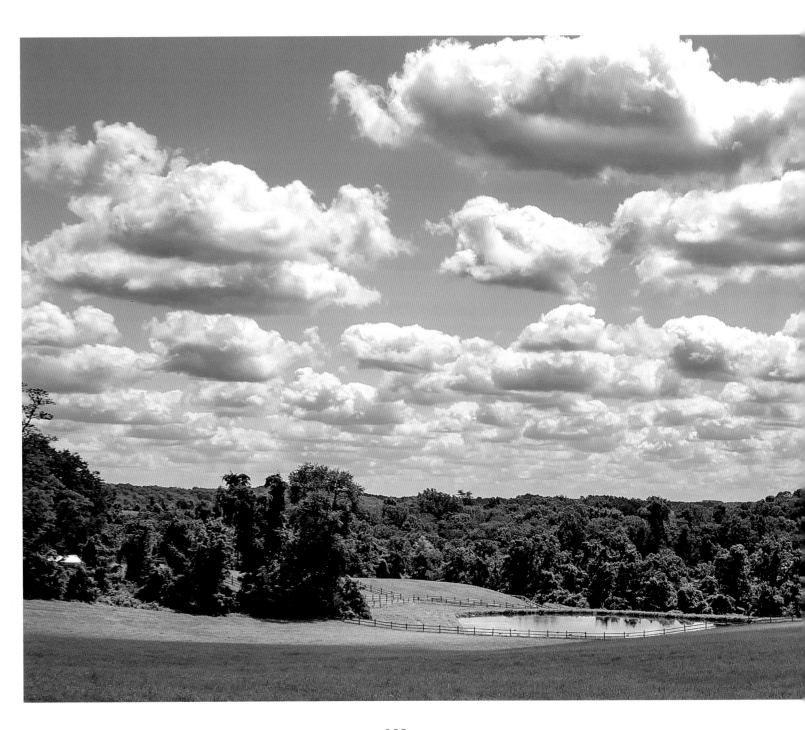

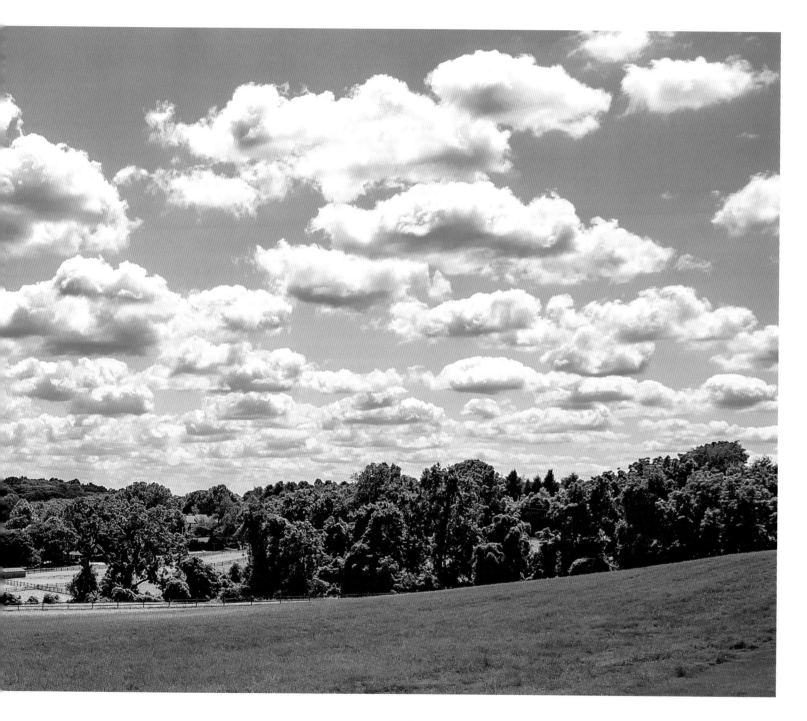

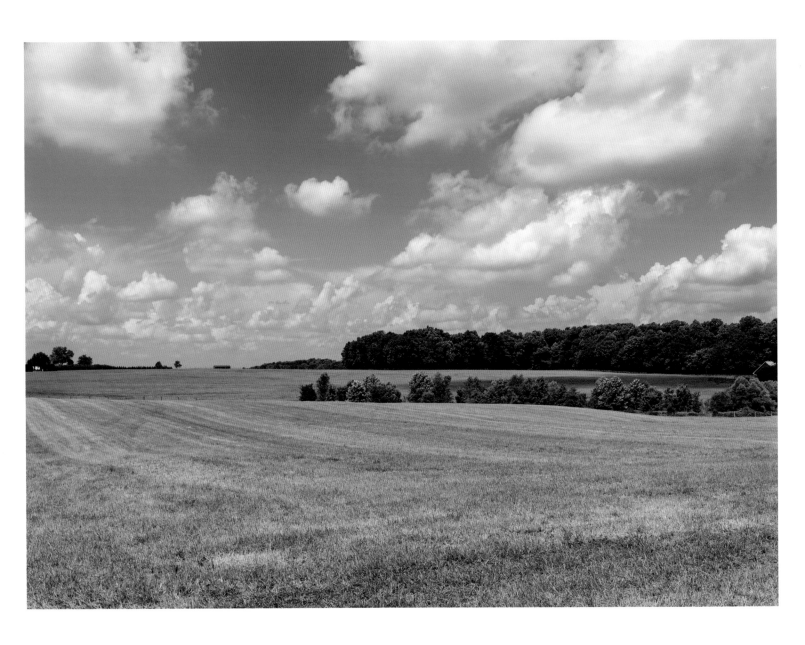

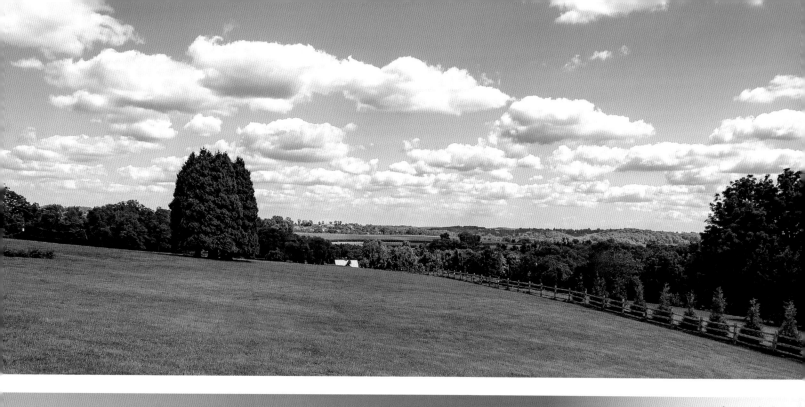

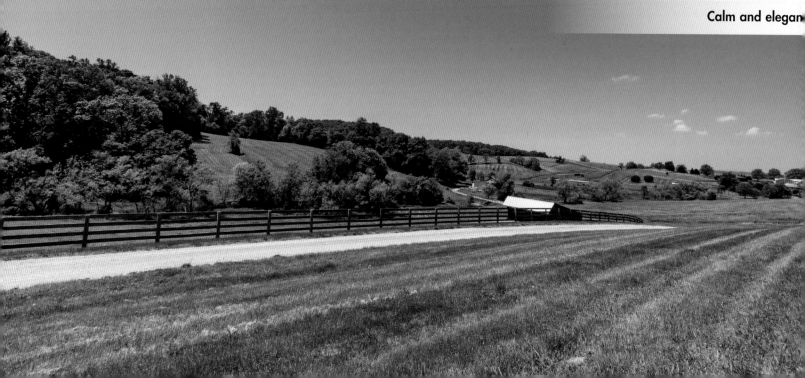

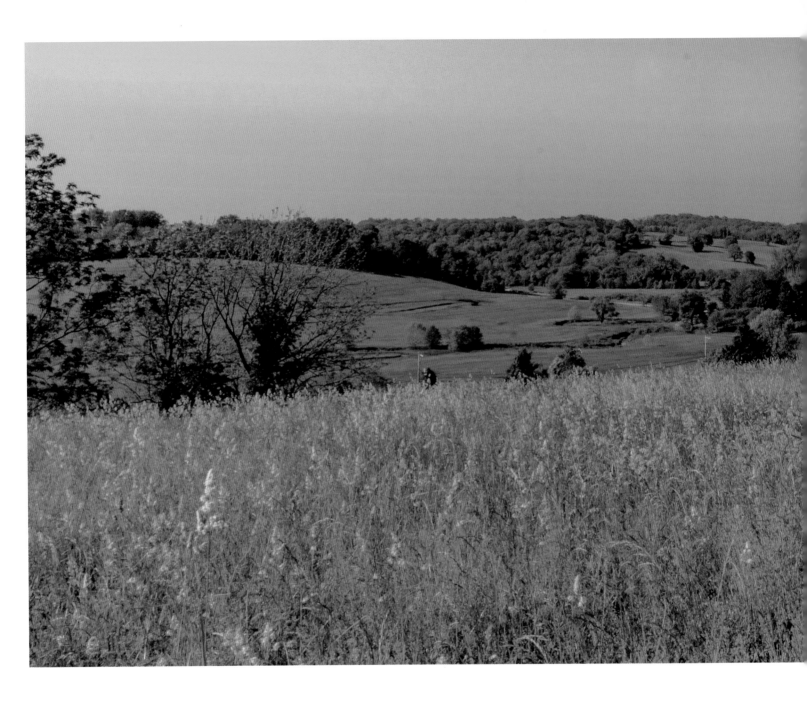

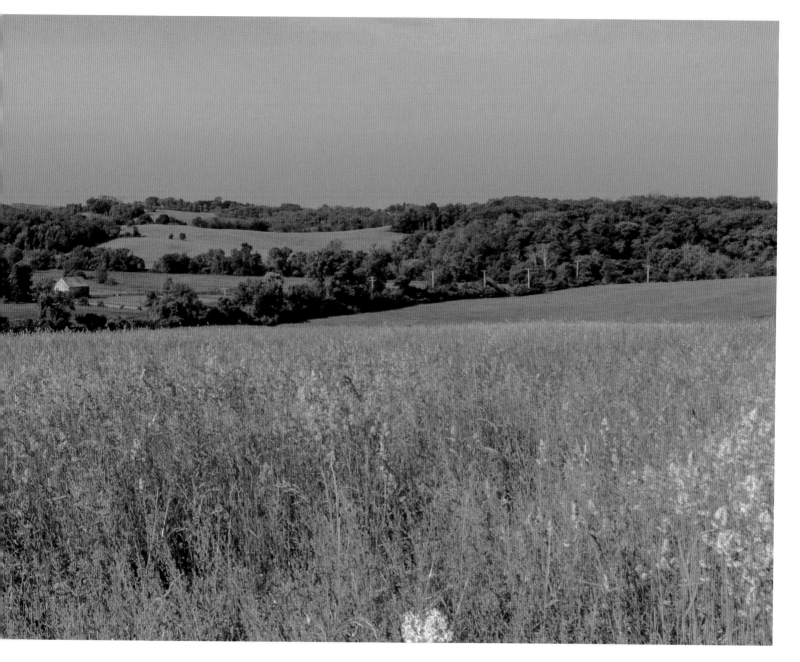

Peaceful and serene

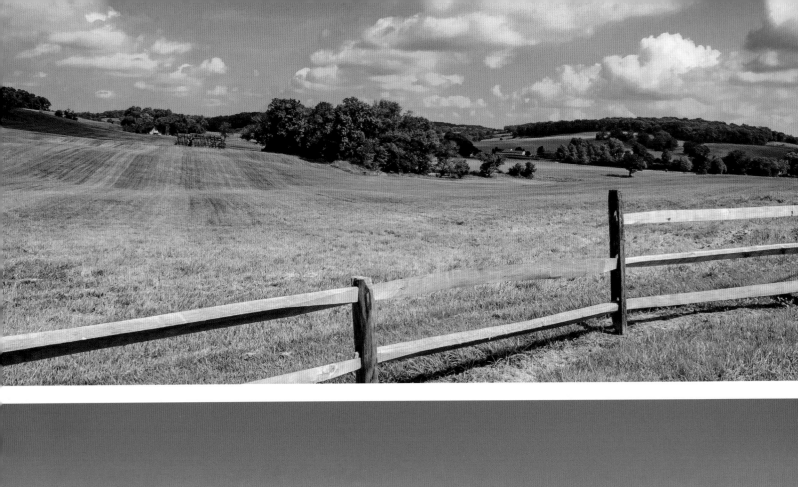
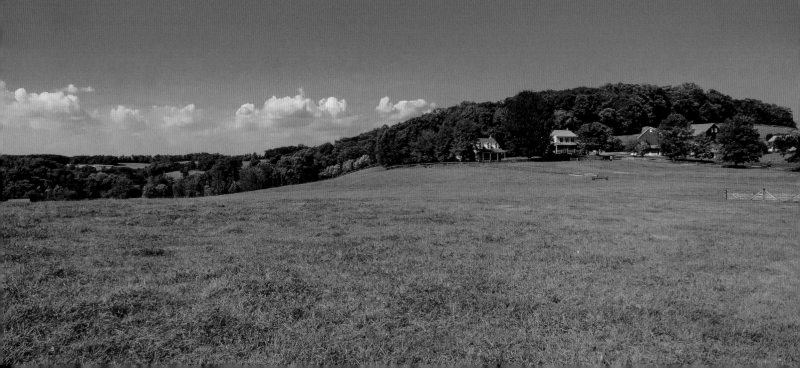

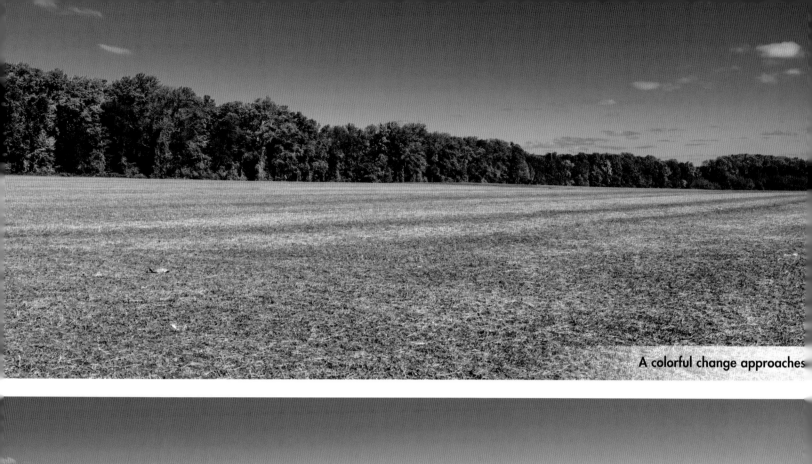
A colorful change approaches

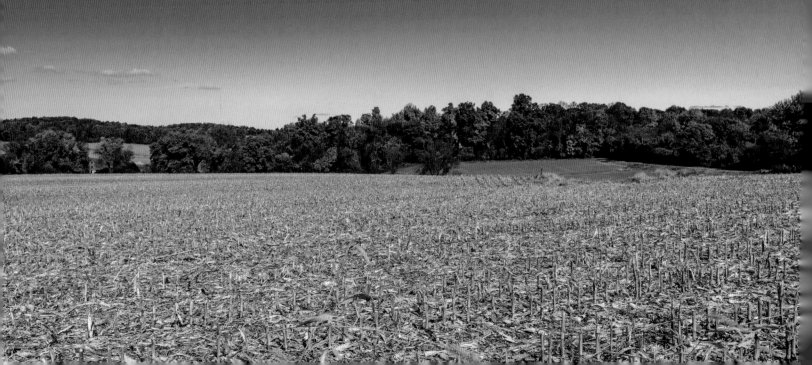

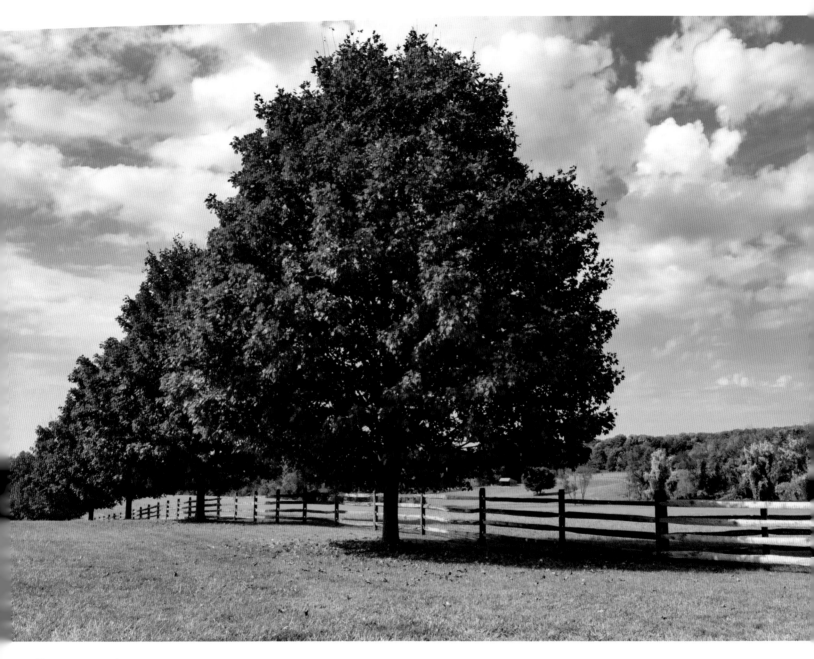

Burnt-orange leaves

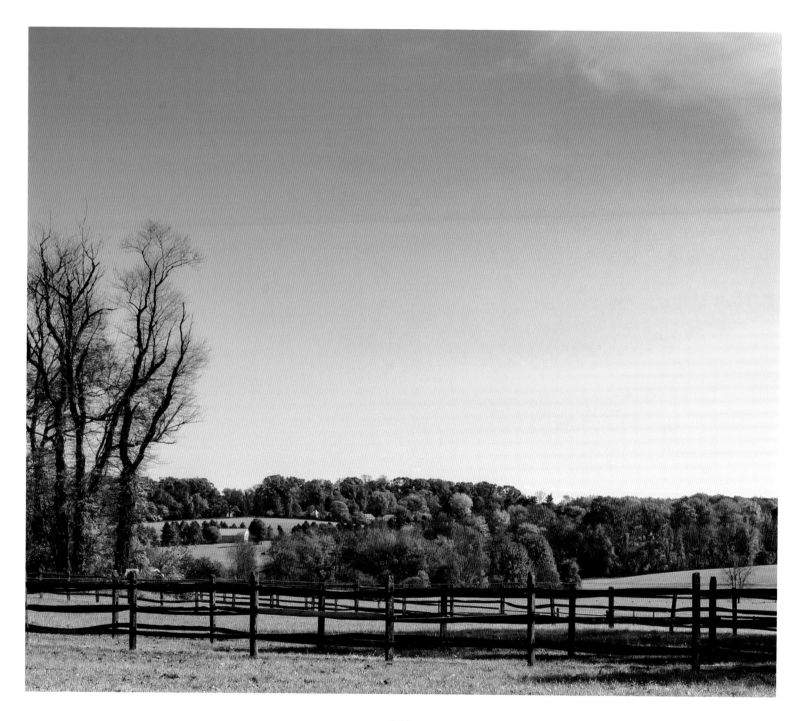

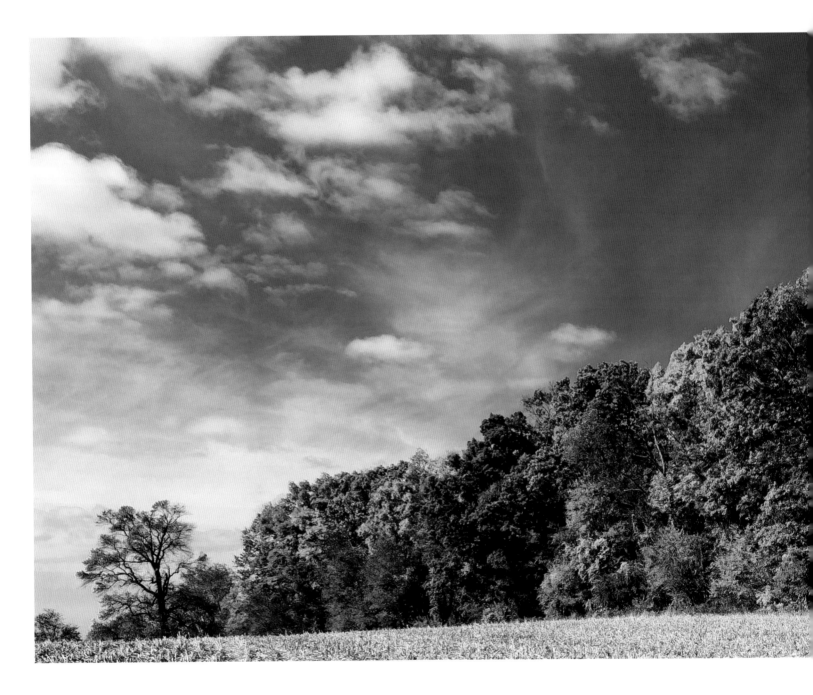

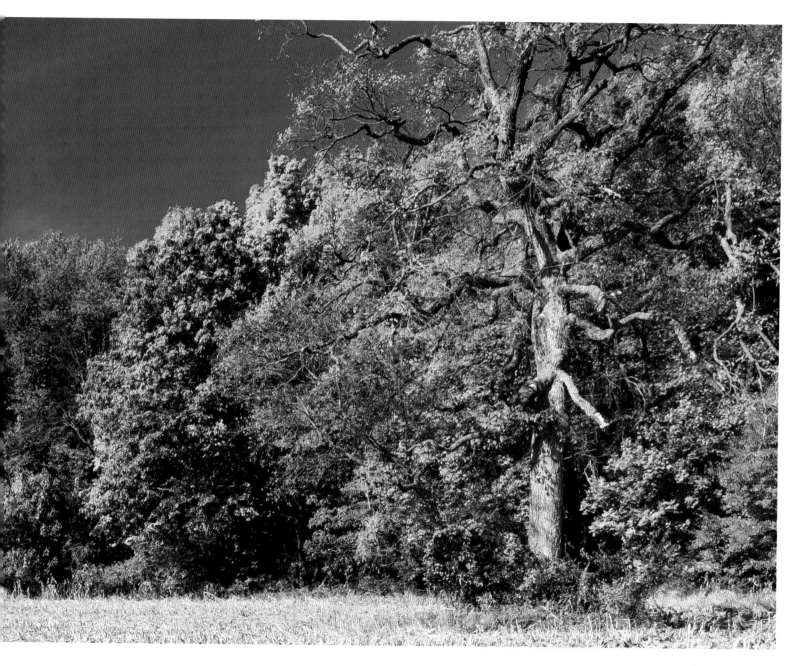

Colorful tree lines

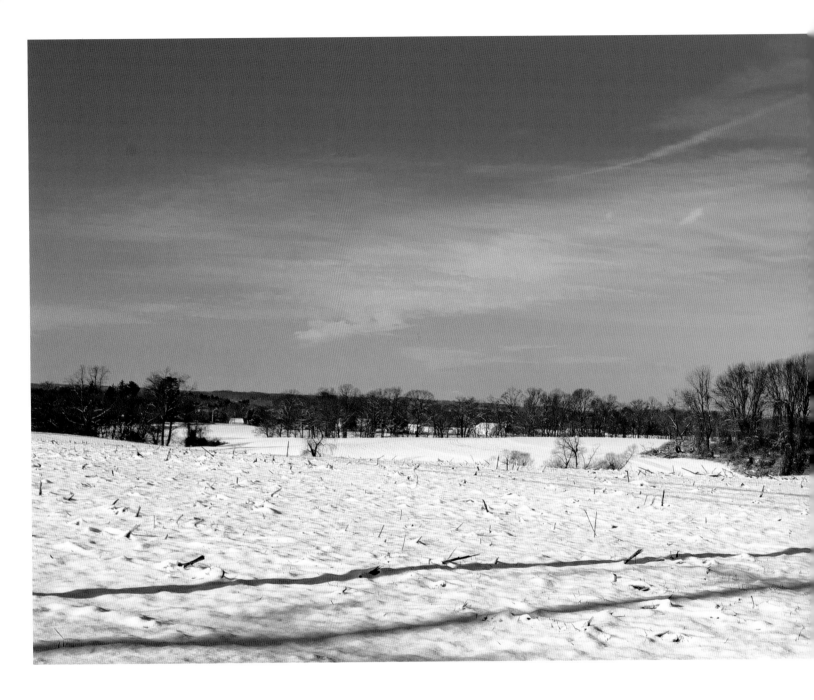

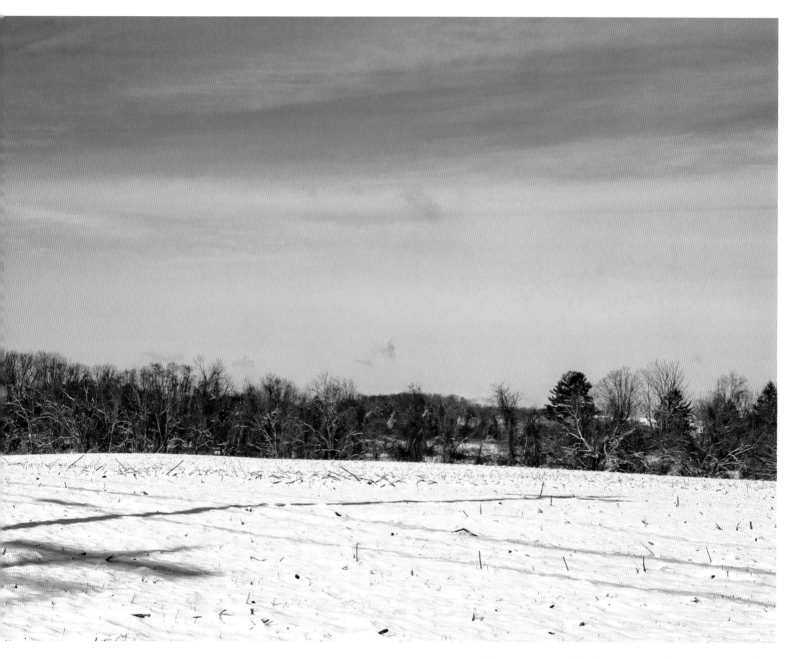

Winter arrives with fields covered in a fresh snowfall.

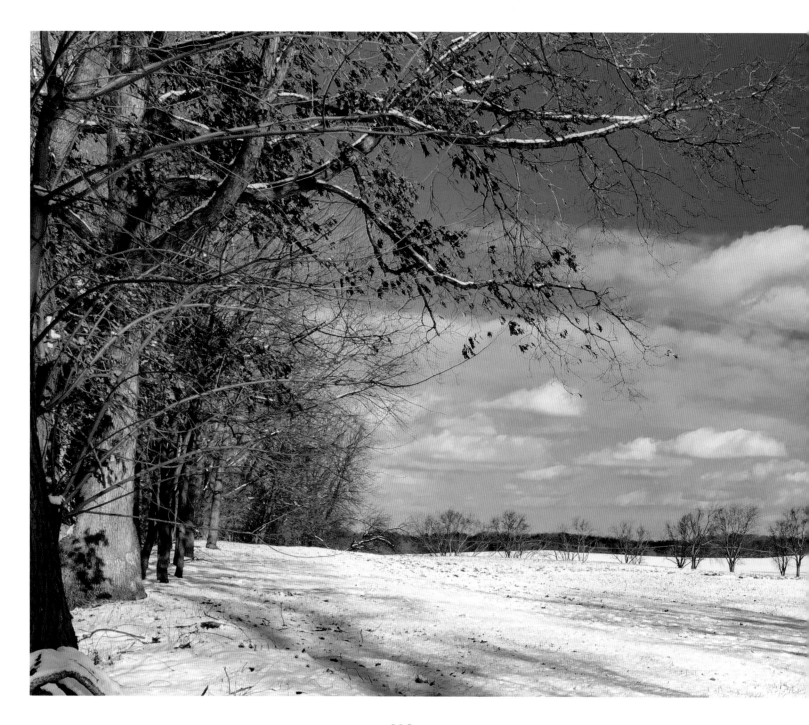

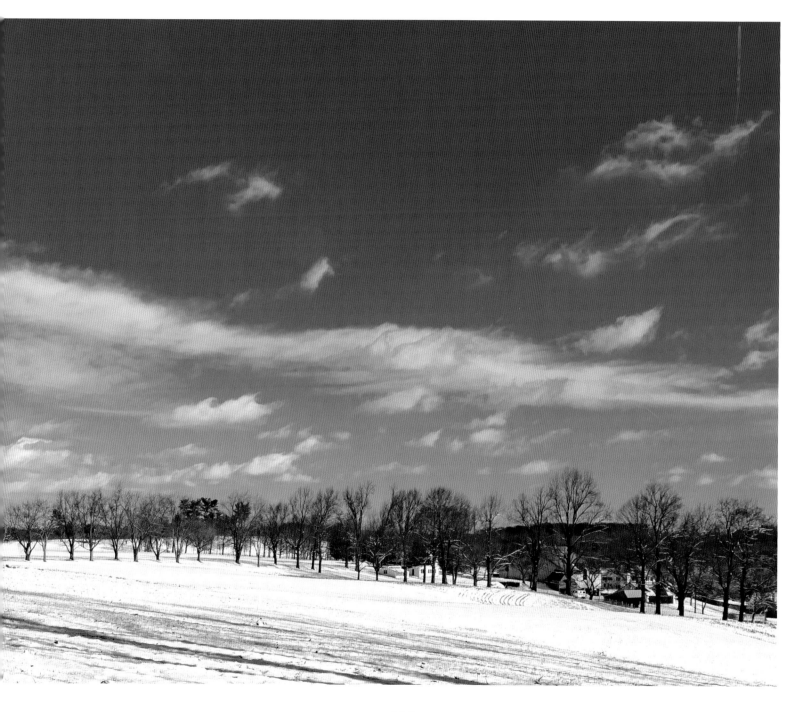

CHAPTER FIVE
RADNOR HUNT

Radnor Hunt, located on Providence Road, is the oldest active fox hunt in the United States recognized by the Master of Foxhounds Association of America. Founded in 1883 in Radnor, Pennsylvania, they moved to their current location in 1931, where they sit on a hundred acres of picturesque views of the countryside. Radnor Hunt is surrounded by over six thousand acres of preserved land wherein the long tradition of fox hunting takes place.

These next photos center on the Radnor Hunt and the two hunts I was given permission to photograph. Special thanks to all members of the Radnor Hunt for allowing me to photograph these fox hunts.

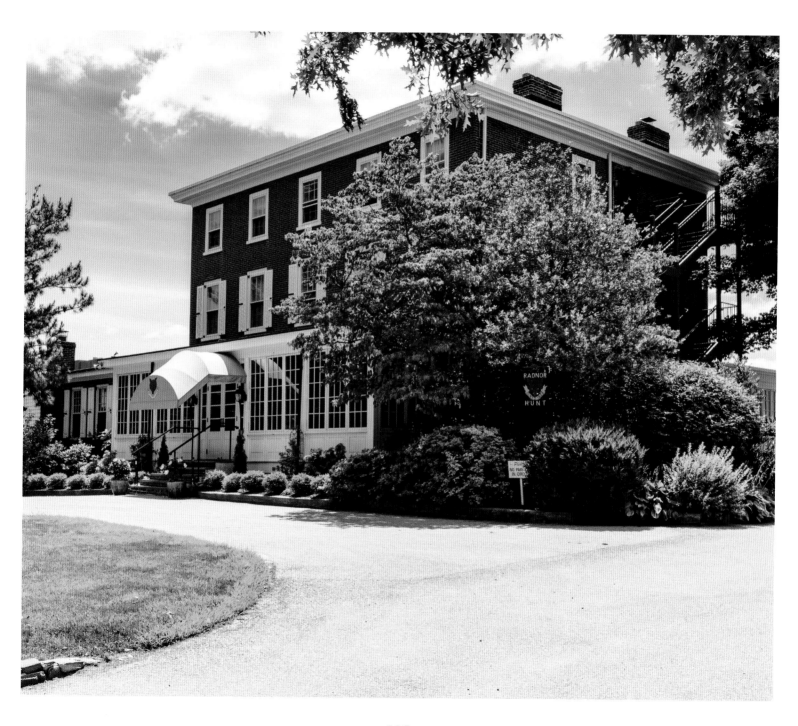

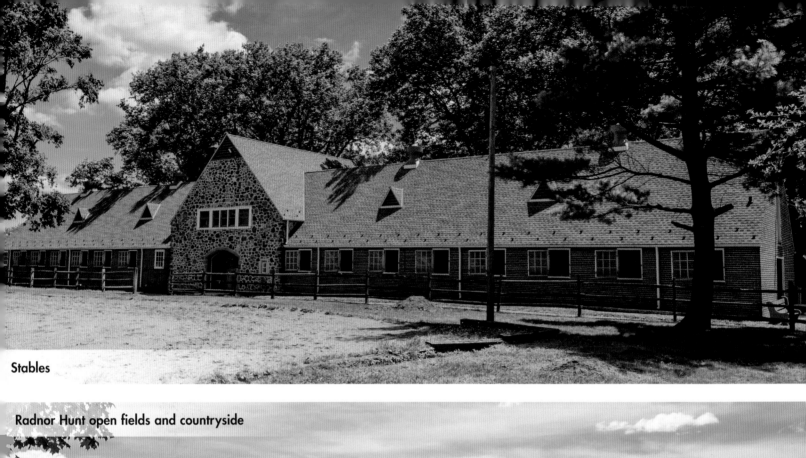

Stables

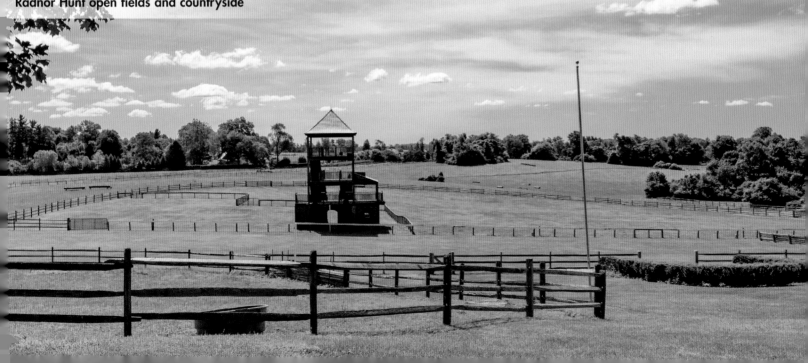

Radnor Hunt open fields and countryside

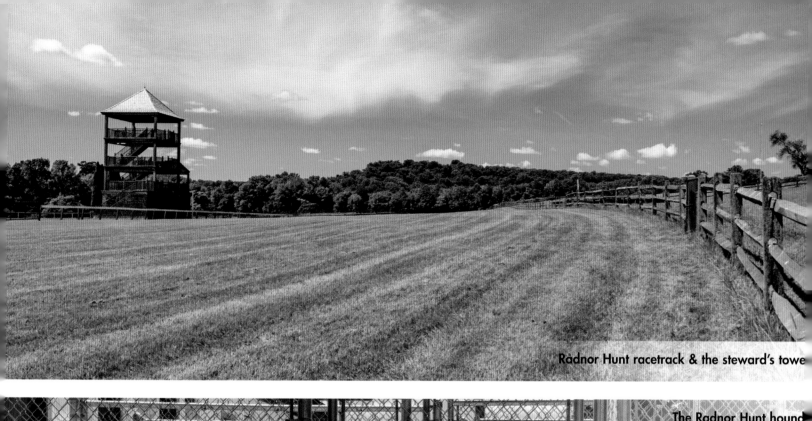

Radnor Hunt racetrack & the steward's towe

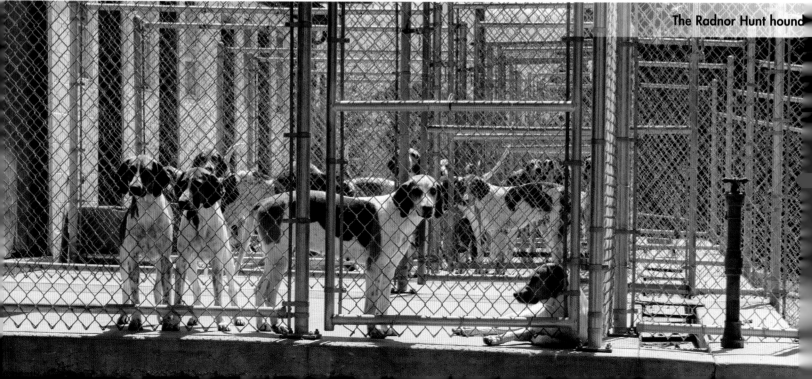

The Radnor Hunt hound

The huntsman

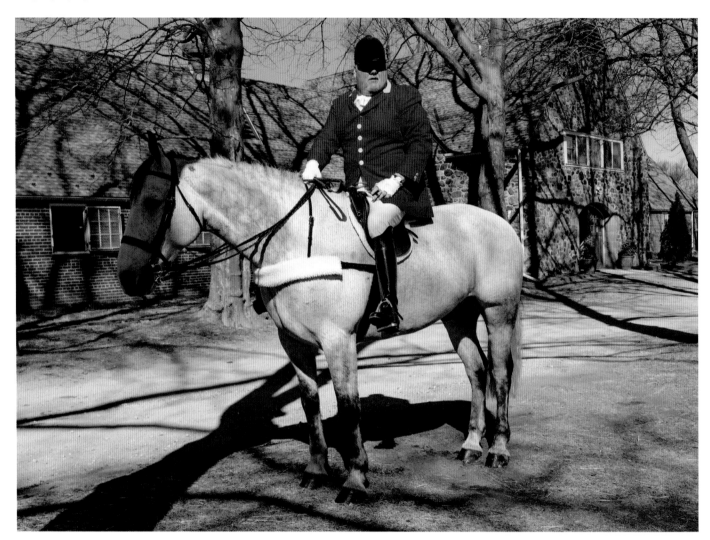

Red fox—flushed

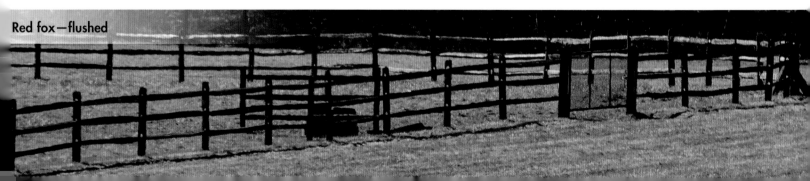

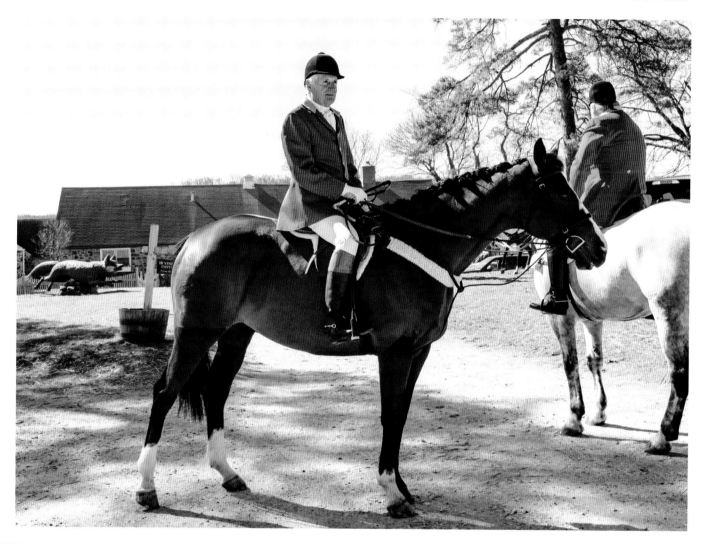

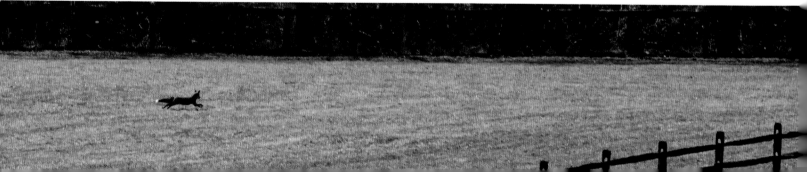

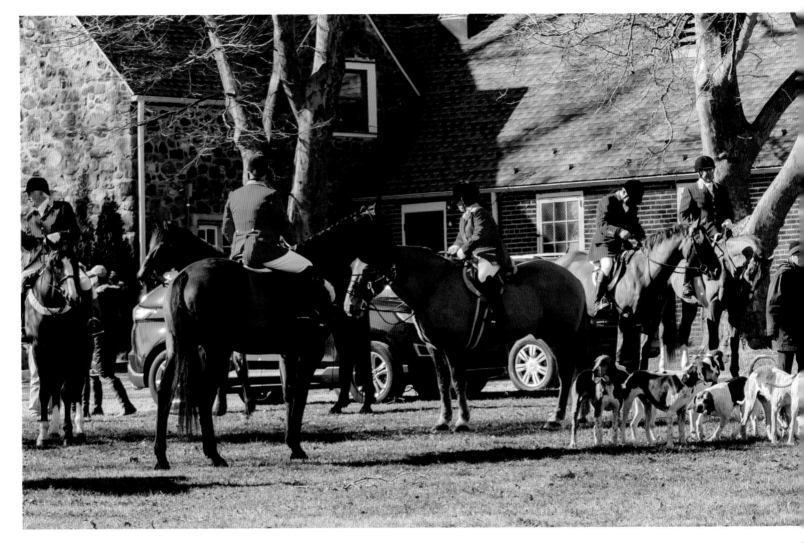

Red fox—full-out run

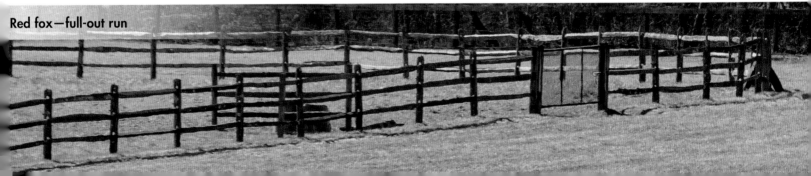

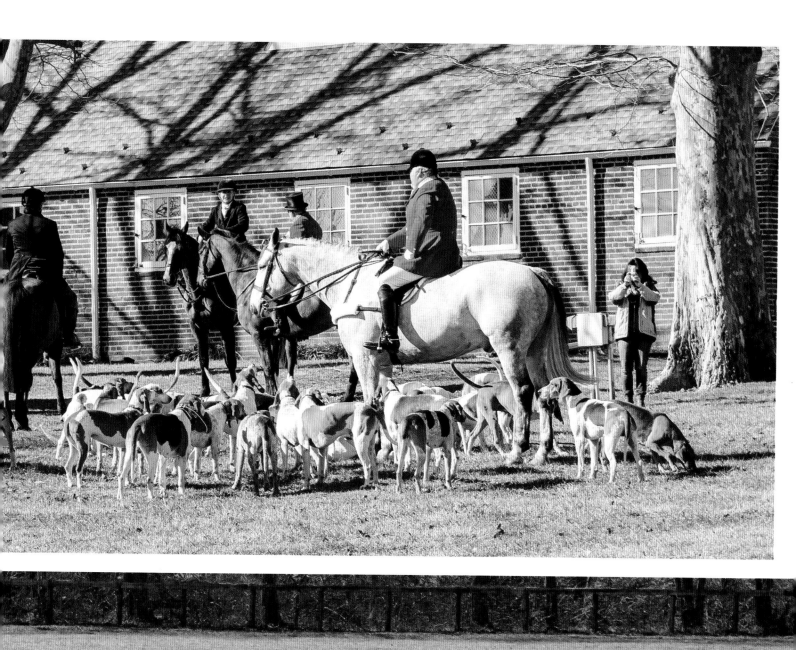

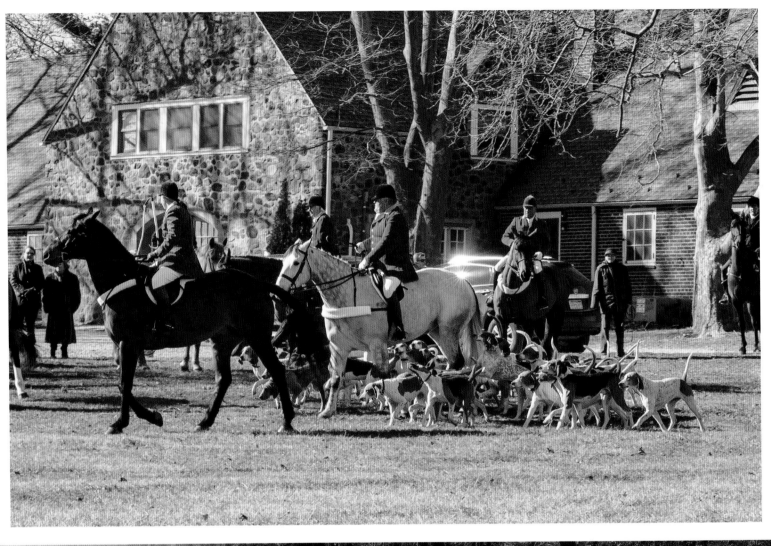

Tally-ho

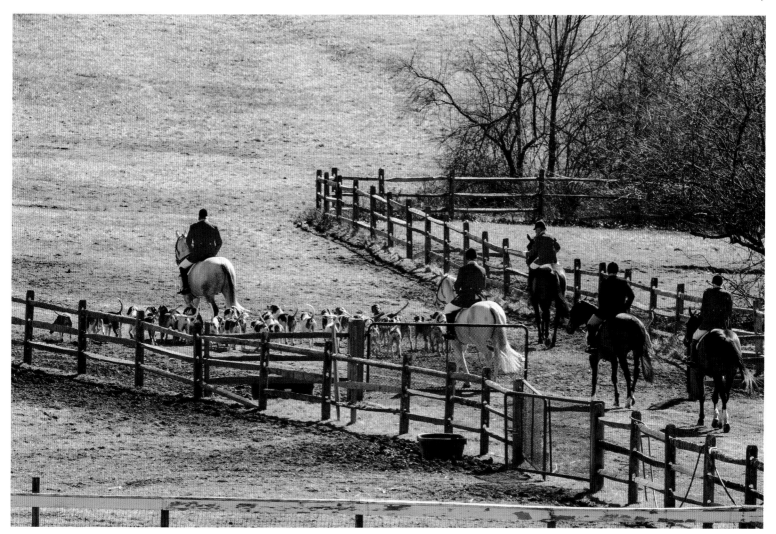

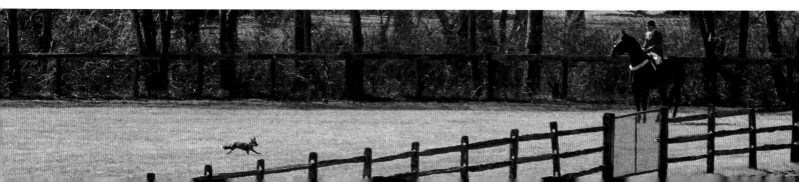

The master waiting for the hounds to cast themselves

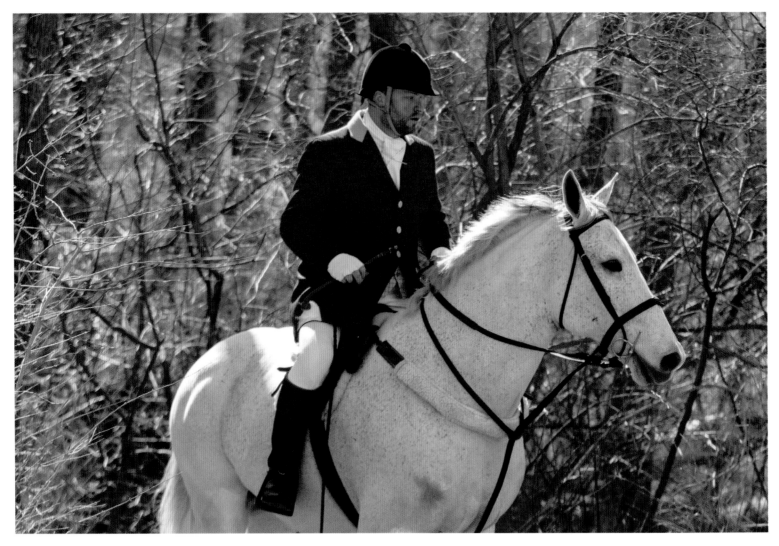

Hounds hitting the line

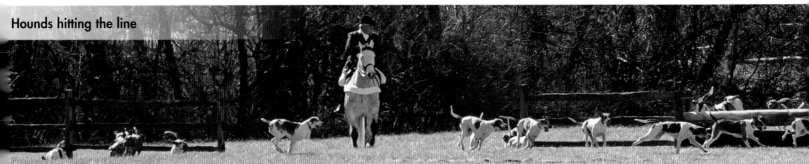

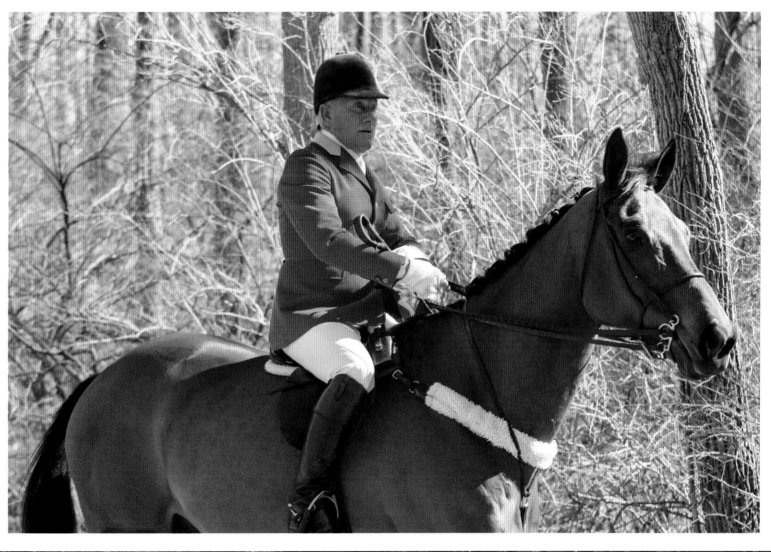

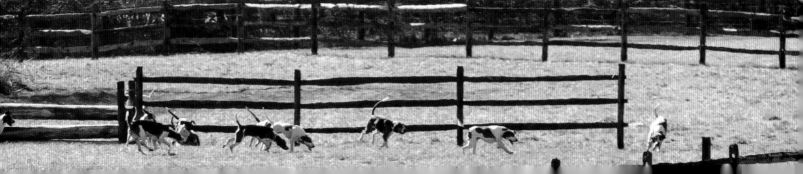

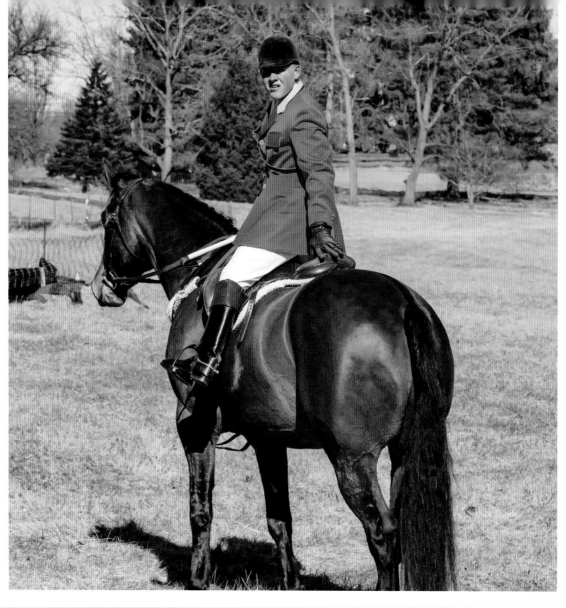

Full cry

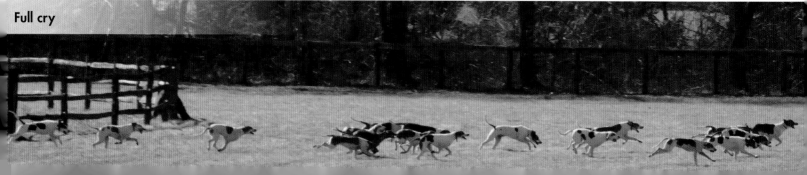

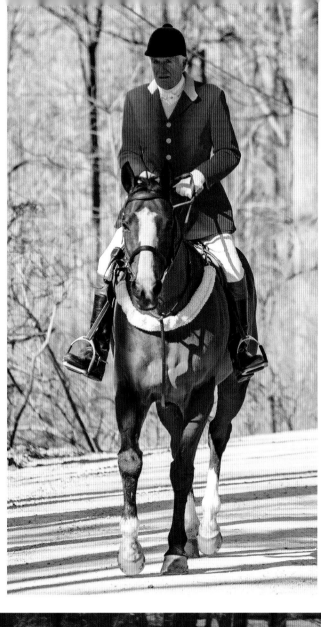

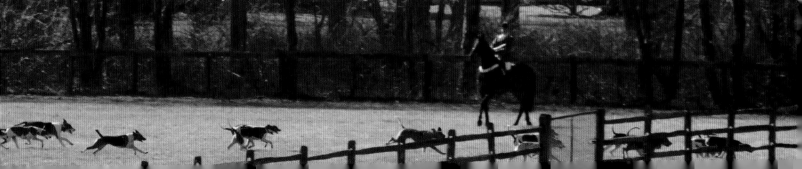

Over the timber

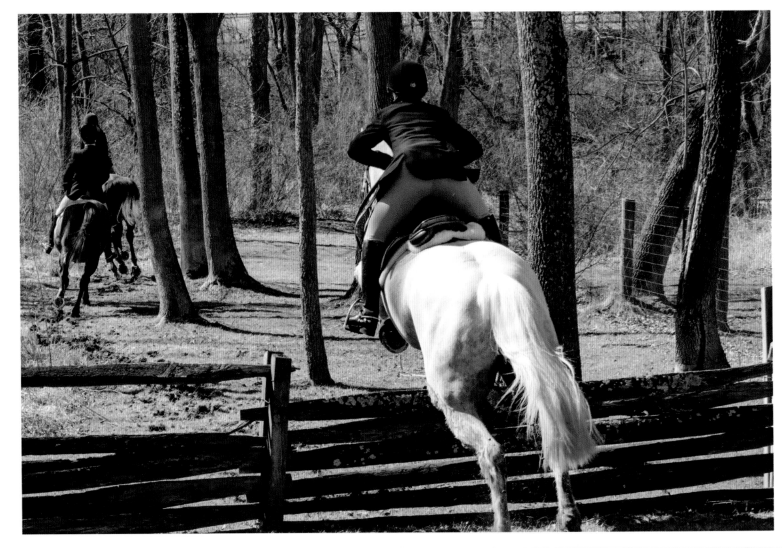

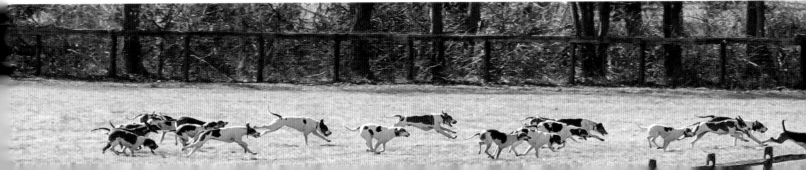

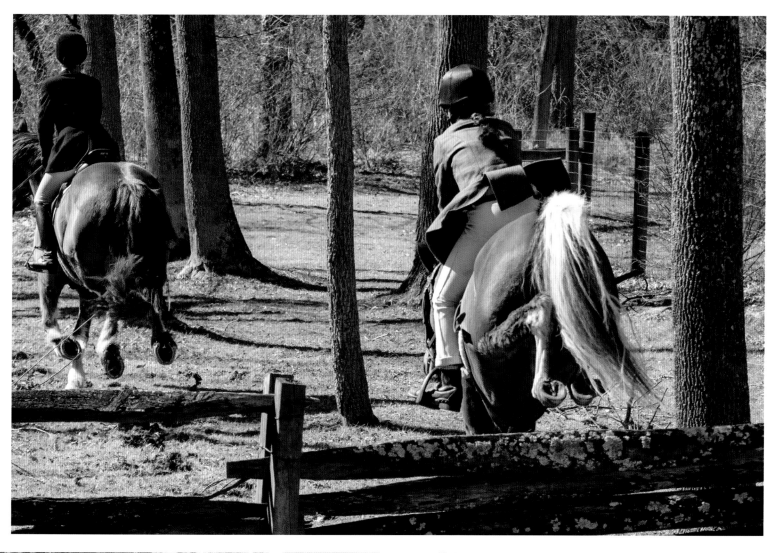
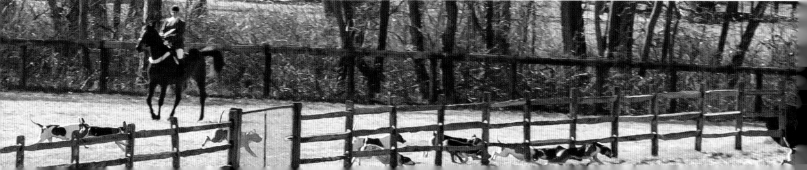

In good form

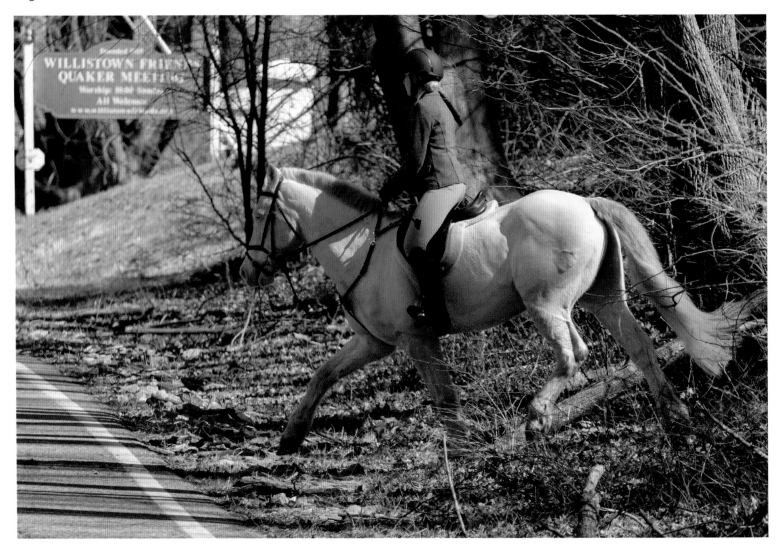

Over the timber

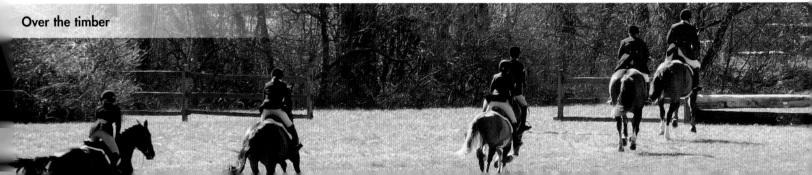

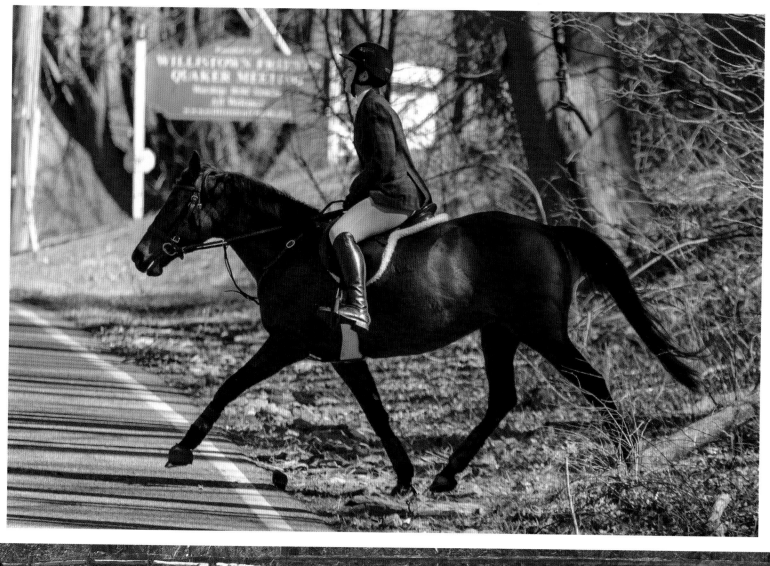

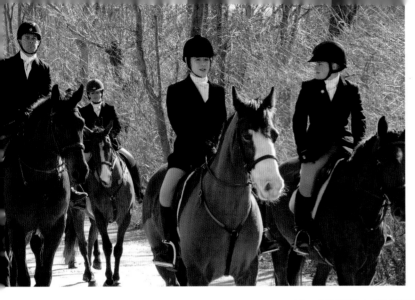

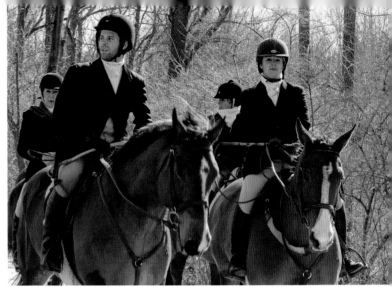

Returning from the hunt

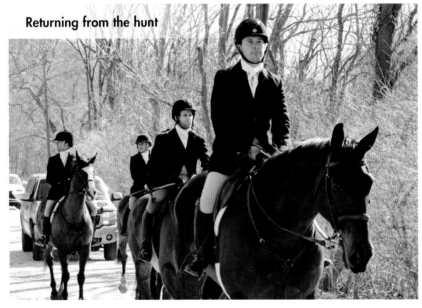

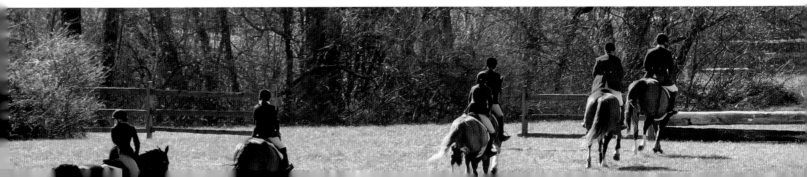

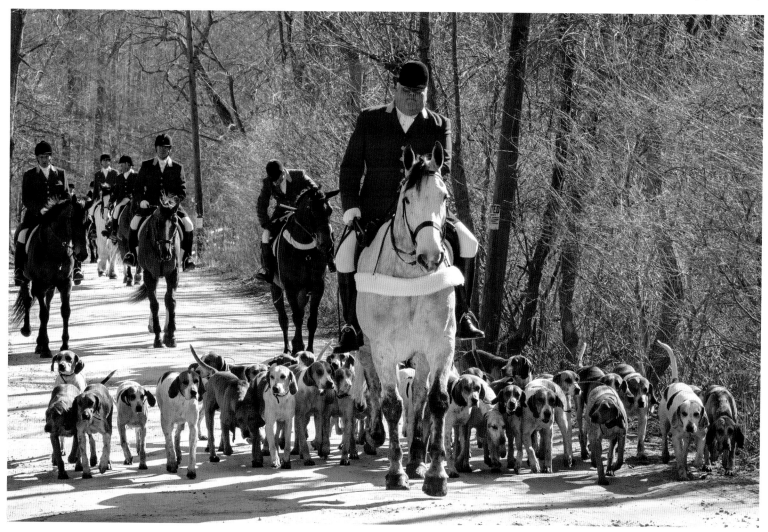

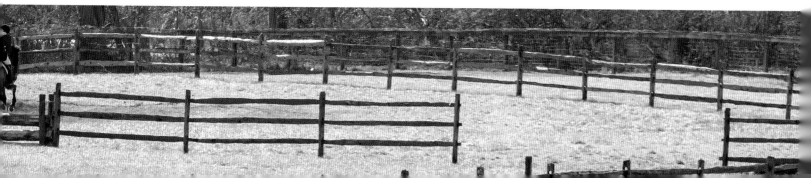

CHAPTER SIX
THE LAND CONSERVANCY FOR SOUTHERN CHESTER COUNTY

The Land Conservancy for Southern Chester County is located at 541 Chandler Mill Road, in Avondale, Pennsylvania. Founded in the 1970s and incorporated as a nonprofit in 1995, their mission is "to ensure the perpetual preservation and stewardship of open space, natural resources, historic sites, and working agricultural lands throughout Southern Chester County."

Many of the images in this book are in fact still here for all of us to enjoy because of the wonderful work from TLC and other conservancy groups located in Chester County.

For more information about the Land Conservancy for Southern Chester County, please check out their website at www.tlcforscc.org.

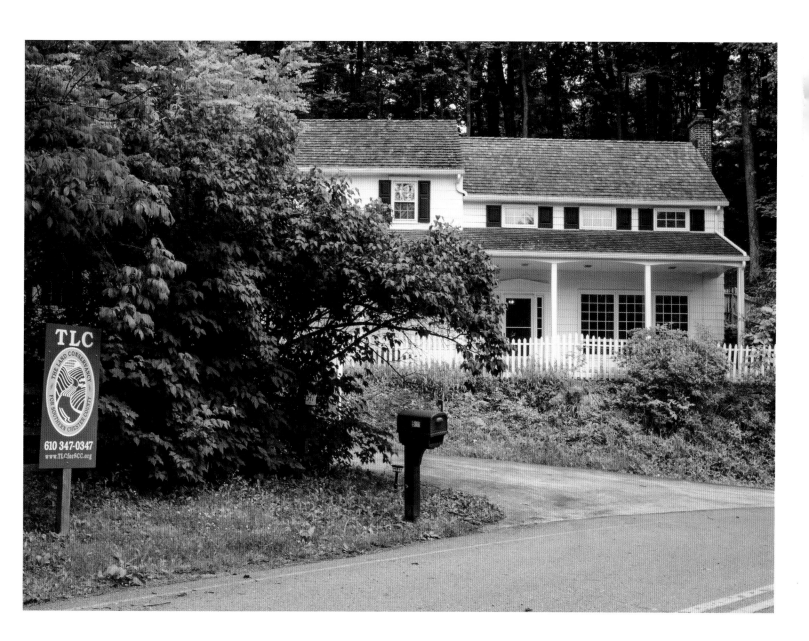

A meadow at the Chandler Mill Nature Preserve

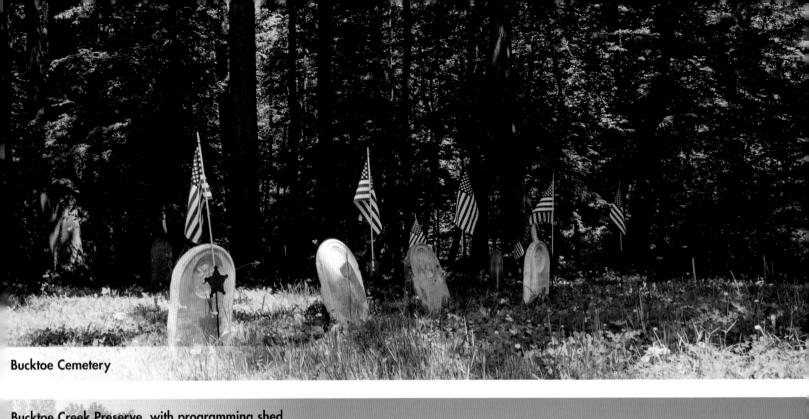

Bucktoe Cemetery

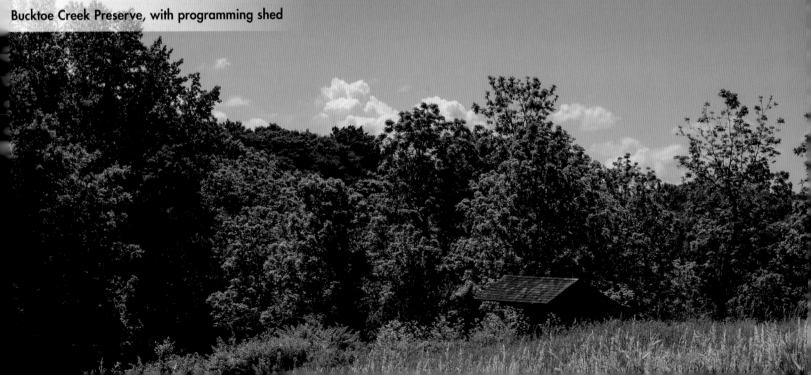

Bucktoe Creek Preserve, with programming shed

Bucktoe Creek Preserve

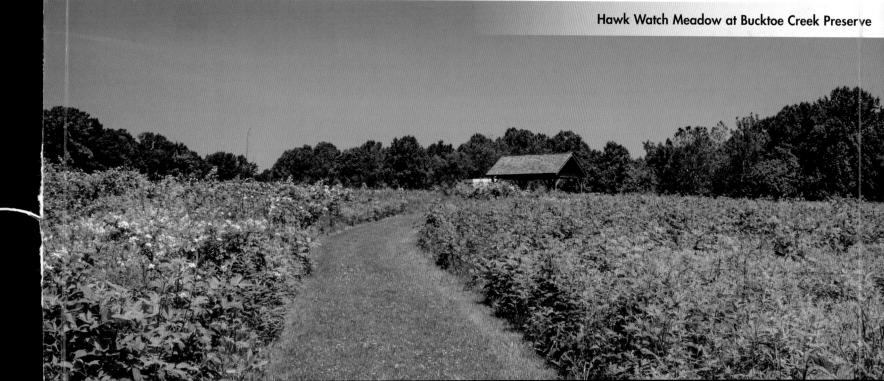
Hawk Watch Meadow at Bucktoe Creek Preserve

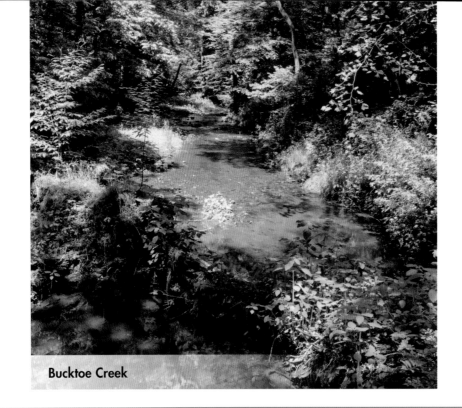

Bucktoe Creek

Programming shed

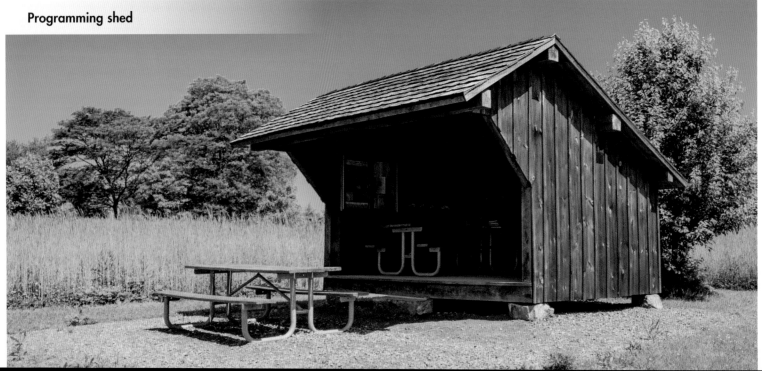

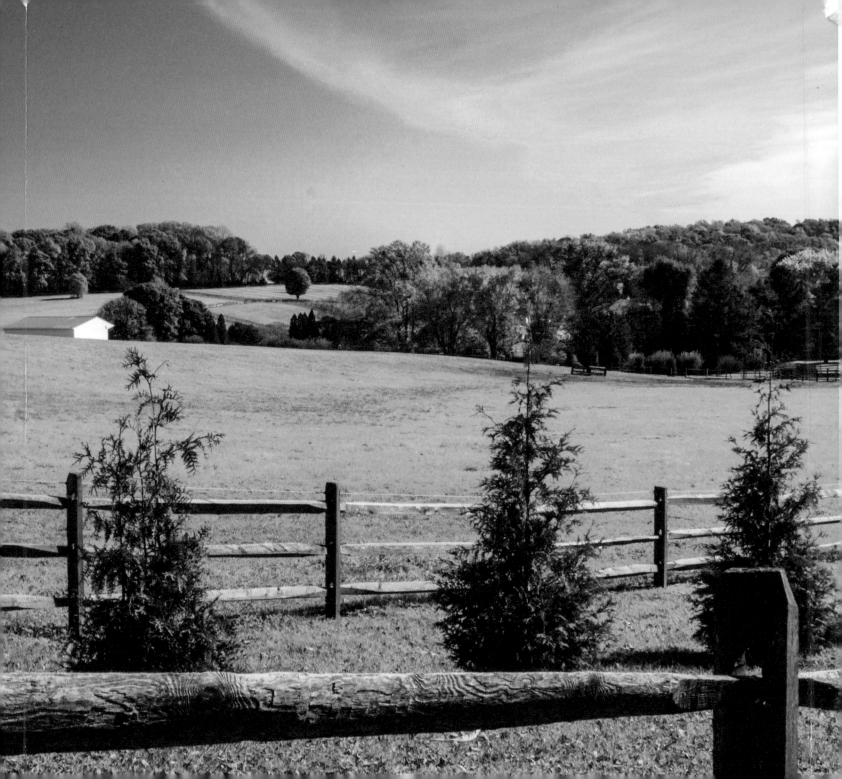